W9-BGL-677

Drawing
Step-by-Step

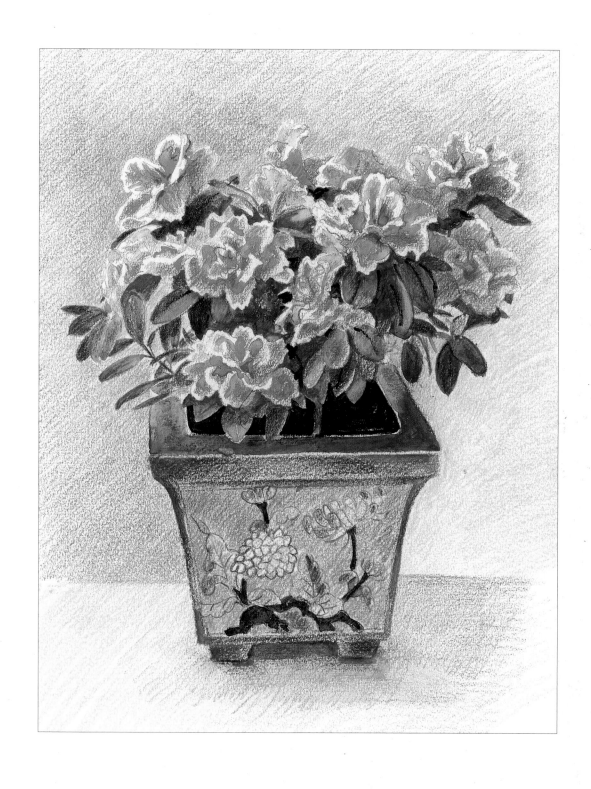

First published in Great Britain 2009

Search Press Limited
Wellwood, North Farm Road,
Tunbridge Wells, Kent TN2 3DR

Reprinted 2010

Based on the following books published by Search Press:

Basic Drawing Techniques by Richard Box (2000)
Water Soluble Pencils by Carole Massey (2001)
Drawing Landscapes by Ronald Swanwick (2001)
Drawing Trees by Denis John-Naylor (2004)
Drawing Pets by Sally Michel (2005)

Text copyright © Richard Box, Carole Massey, Ronald Swanwick,
Denis John-Naylor and Sally Michel, 2009

Photographs by Charlotte de la Bédoyère,
Search Press Studios and by Roddy Paine Photographic Studios

Photographs and design copyright © Search Press Ltd. 2009

All rights reserved. No part of this book, text, photographs or
illustrations may be reproduced or transmitted in any form
or by any means by print, photoprint, microfilm, microfiche,
photocopier, internet or in any way known or as yet unknown, or
stored in a retrieval system, without written permission obtained
beforehand from Search Press.

ISBN: 978-1-84448-439-3

The Publishers and author can accept no responsibility for any
consequences arising from the information, advice or instructions
given in this publication.

Readers are permitted to reproduce any of the drawings in this
book for their personal use, or for the purposes of selling for
charity, free of charge and without the prior permission of the
Publishers. Any use of the paintings for commercial purposes is
not permitted without the prior permission of the Publishers.

Suppliers
If you have any difficulty obtaining any of the materials and
equipment mentioned in this book, please visit the
Search Press website: www.searchpress.com

Publisher's note
All the step-by-step photographs in this book feature the authors,
Richard Box, Carole Massey, Ronald Swanwick, Denis John-Naylor
and Sally Michel demonstrating drawing techniques. No models
have been used.

Printed in Malaysia

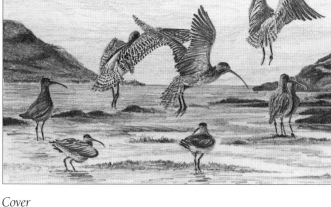

Cover
Banana Plant by Carole Massey

Page 1
Azaleas by Carole Massey

Above
Curlews by Ronald Swanwick

Below
Dog portrait by Sally Michel

Opposite
Otter by Richard Box

Page 4
Old Leaves and New Buds by Denis John-Naylor

Page 5
Blue Hyacinths by Carole Massey

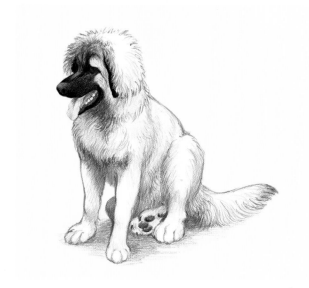

Drawing
Step-by-Step

RICHARD BOX, DENIS JOHN-NAYLOR, CAROLE MASSEY, SALLY MICHEL & RONALD SWANWICK

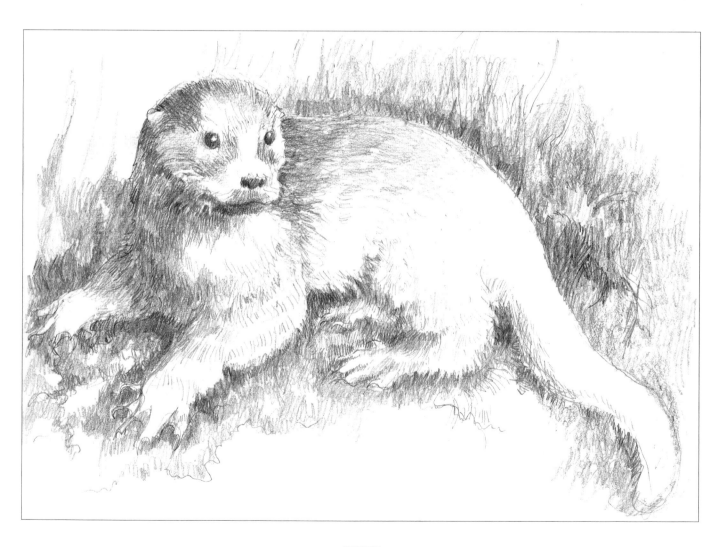

SEARCH PRESS

Contents

Materials and equipment

Getting started need not be expensive. This section covers ordinary (or 'dry') drawing first, then from page 9 it shows what you will need if you want to explore water soluble pencils, which combine drawing with painting techniques. For dry drawing you need just a few pencils, a craft knife, an eraser, some paper, a drawing board and some clips. You can add more to your work box as you become more confident.

Dry drawing media

Graphite pencils These are the most popular pencils for drawing. They are available in a range of leads, graded from hard (9H) to soft (9B). Hard leads usually make sharp pale marks, whereas soft leads make less precise and darker marks. All graphite leads create a shiny surface.

Pierre Noire pencils These yield a much darker tone than graphite pencils and create a matt surface. They are graded in a range from hard (H) to soft (3B).

Carbon pencils These create tonal values midway between those made by graphite and Pierre Noire pencils. They are available in a hardness range of 2H to 3B.

Charcoal This is available in stick and pencil form. Charcoal sticks, which are made in various thicknesses, tend to be softer than the pencils. Pencils have compressed charcoal cores, and are available in a range of hardnesses. Both types create a more immediate and dramatic result than any of the pencils mentioned above.

White pencils These are normally used on coloured or tinted paper; either on their own or, more usually, in conjunction with other media to accentuate highlights.

Sanguine and sepia pencils These provide a useful alternative to the white, black and grey tones made by 'black' and white pencils. Their lead structure is similar to that of charcoal, and contact with the paper is immediate.

Coloured pencils These are very popular, and there are lots of different ranges available. Most of them are transparent in nature so that other colours can be made by layering one over another.

Pastels and Conté crayons Pastels are available in stick or pencil form. Stick pastels make more immediate marks than the slightly harder pastel pencils. The marks made by Conté crayons are midway between those of pastel sticks and pastel pencils. Both media are opaque by nature, so other colours can be created by mixing them on the paper. This opacity also gives them excellent covering power. Thus they have the opposite quality of the coloured pencils.

Craft knife This is best for sharpening pencils (rather than a pencil sharpener). It allows you to form a long lead – you can then use the side of the lead to create broad marks, and the tip to make fine details.

Eraser This is used to remove unwanted marks and to identify highlights. Very soft putty erasers are best as they do not smear the drawing or scuff the surface of the paper.

> **Note** *Charcoal, chalk, sanguine and sepia pencils, pastels and Conté crayons yield an excess dust which you will need to blow away during the course of your drawing.*

Opposite

A selection of the wide range of drawing media available.

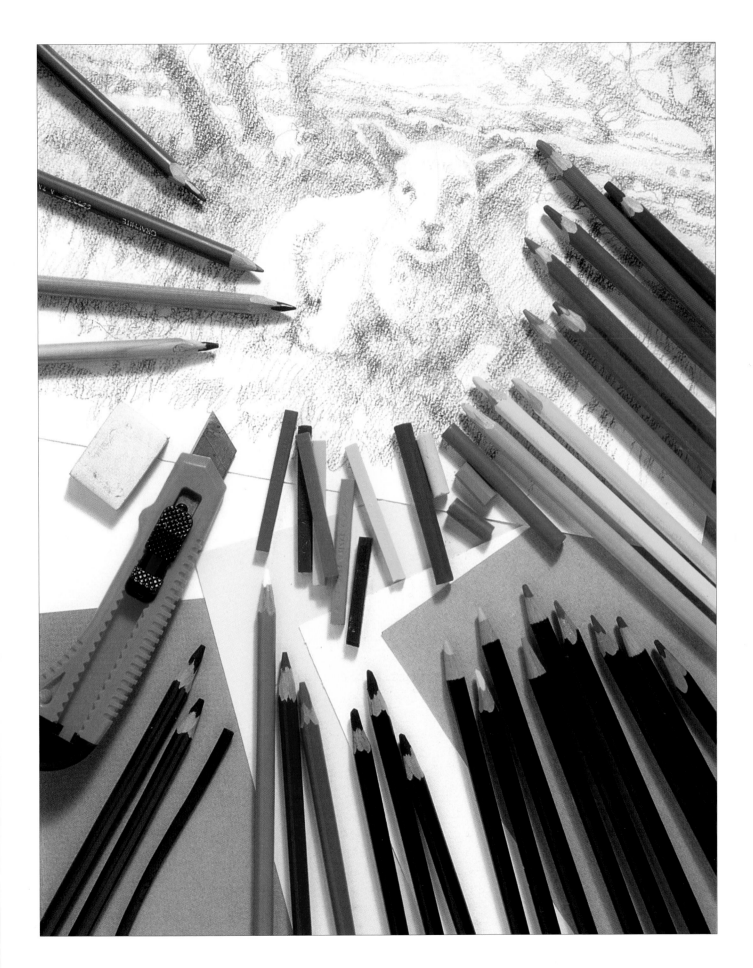

Stretching paper for use with water soluble pencils

Light- and medium-weight papers may need to be stretched to prevent the surface cockling when you add water. To do this, you will need a drawing board and four lengths of brown gumstrip paper 36mm (1½in) wide, cut slightly longer than the sides of your paper. Wipe over the board with a sponge and clean water, then lay your paper on the board and wet its surface, pushing out any creases. Moisten the gumstrip with your sponge and stick it to the paper, overlapping the edge by about 10mm (³⁄₈in). Repeat on the remaining sides, ensuring that the gumstrip is stuck well down. Leave the paper to dry naturally. Paper stretched in this way will always dry completely flat. When your painting is completely dry, remove it by cutting between the paper and the gumstrip with a sharp knife.

Brushes

A good brush will always keep its shape and form a good point when wetted. Good quality synthetic or synthetic/sable blend brushes have the right 'spring' and resilience needed to push the pigment across the surface of the paper. A No. 8 and a No. 5 are suitable for most work. For a big area of wash, you might find a No. 12 or No. 14 brush useful.

Top: No.5 round
Middle: No. 8 round
Bottom: No.10 round.

Sketchbooks

Get into the habit of keeping a sketchbook. Draw as often as you can – figures, animals, trees, buildings, clouds – anything and everything! Sketching is the best way to improve your powers of observation and drawing ability, and it will also give you a ready supply of material to include in your paintings. If you do not have much time, you can jot down notes to refer to later. Water soluble pencils are an ideal sketching medium because you have the facility of line, colour and wash in one (see left), but you can use any drawing medium.

Other materials for use with water soluble pencils

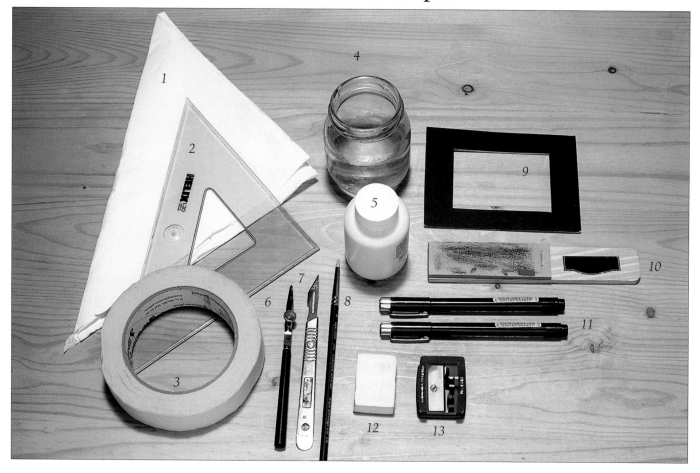

1. **Absorbent tissue** *for mopping up spills and blotting damp areas.*

2. **Small set square** *for measuring right angles.*

3. **Masking tape** *for fixing paper to your drawing board.*

4. **Pot** *to hold water.*

5. **Masking fluid** *for reserving fine details, or for use on areas which might otherwise be lost when you add a wash. When the painting is completely dry, remove it by rubbing lightly with your finger, or use an eraser.*

6. **Ruling pen** *for applying masking fluid.*

7. **Scalpel** or **craft knife** *to keep your pencils very sharp.*

8. **Silicone shaper** *for use with masking fluid.*

9. **Viewfinder** *for framing a view.*

10. **Sandpaper block** *for maintaining a sharp point on the pencils.*

11. **Drawing pens** *for defining the drawn image on tracing paper.*

12. **Kneadable (putty) eraser** *for drawing in highlights or for using in small areas of your picture. It can be shaped for easy use and leaves no residue.*

13. **Jumbo pencil sharpener** *to use with stubby pencils.*

Not shown:

Drawing board *I use a piece of 6mm (¼in) medium-density fibreboard about 470 x 360mm (18½ x 14¼in).*

Gumstrip paper *use this to fix your work to your drawing board when stretching paper.*

Sponge *to moisten the gumstrip paper.*

> **Note** *there is no palette listed as you do not need one with water soluble pencils.*

BASIC DRAWING TECHNIQUES

by Richard Box

*I pray every day that God make me like a child, that is to say that he will let
me see nature in the unprejudiced way that a child sees it.*

Jean-Baptiste Camille Corot (1796–1875)

Does the idea of drawing fill you with dread? If so, simply say to that negative and
irrelevant idea, 'not today thank you very much, I am on an adventure!' My students
learn this by heart in order to dispel imagined ideas of fear of failure, ridicule and not
knowing how to start. Very soon they learn to focus on the reality of the *process* of
drawing as an adventure, a means of discovery and a way of loving all the beauties that
nature has to offer us. John Ruskin said, 'I would rather teach drawing that my pupils
may learn to love nature than to teach the looking at nature that they may learn to
draw.' Now you have this opportunity.

Henry Moore also said something most useful to help us concentrate on the
process of drawing: 'Drawing is a means of finding your way about things, and a way
of experiencing more quickly, certain tryouts and attempts.' Notice that he avoids
mentioning 'results'! End results certainly occur. However, they are dependent on the
means. Once we have learnt the means – and even learnt to enjoy them – the end
must come. Even when an 'end' arrives it leads us on to another. Therefore, drawing
needs to be viewed as a continuing voyage – an adventure – with pauses on the way;
rather like any drawing is never *really* finished, as Paul Gardner said of painting, 'it
simply stops at interesting places.'

The purpose of this section is to provide both theoretical and practical help to all of
you who wish to draw and learn about the wonderful nature of drawing itself. We shall
be exploring the qualities of the materials and equipment we use and the surface upon
which we work. We shall investigate the properties of line, tone, texture and colour.
We shall learn ways of looking at the natural world so that we may see it more clearly
and perceptually, in order to express our responses in each of our own unique and
individual ways.

Believe it or not, we all used to draw once. Drawing is a pre-literate language. Before
we learned to read, write and do arithmetic we all drew and no-one taught us. You had
once started this adventure, maybe the pause between then and now is longer than
you care to admit, but you are now simply continuing from whence you left it. Like the
child you once were, become again absorbed, free from inhibitions and full of wonder
in your exciting adventure.

Opposite
Morning Glories
265 x 420mm (10½ x 16½in)
Coloured pencils on cartridge paper.

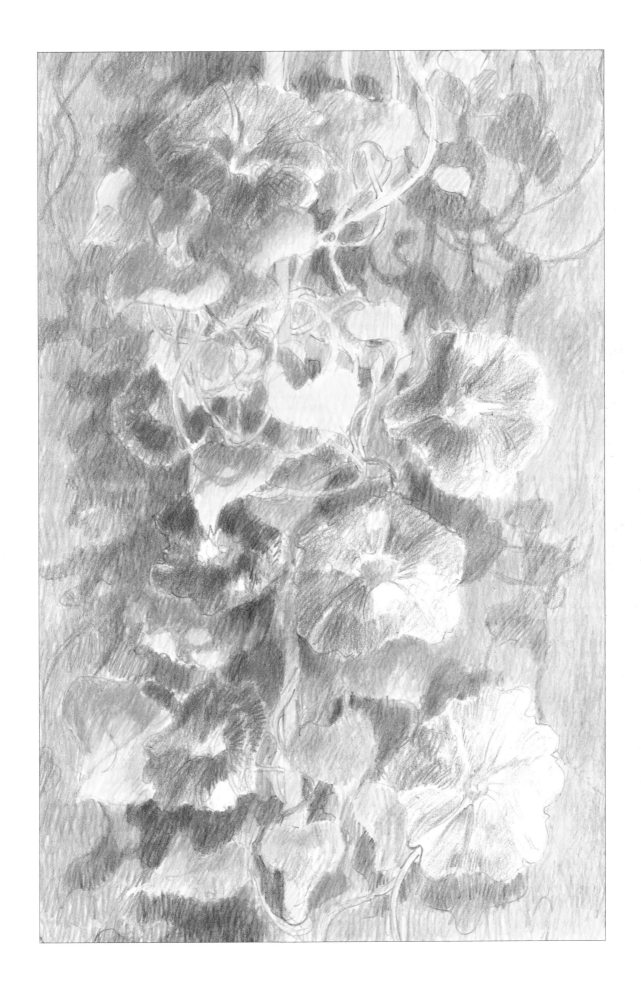

13

Pencils

Become like a child again and explore the nature of pencils and paper without preconceived ideas and in an unprejudiced way. Discover what they are like and what they like to do. Children wonder at such marvels and, with wisdom adults may reinstigate this state – Plato said, 'Wonder is very much the affection of a philosopher'.

In this chapter I show how to make different marks on the paper, I introduce you to tone and texture, then take you, step by step, through a simple graphite pencil landscape.

Making marks

The photographs on this page show how you can create different marks on the paper: you can vary the way you hold the pencil; you can work the pencil stroke from the wrist or from the knuckles; and you can work with either the tip or the side of the pencil lead.

The quality of the marks also varies with the type and grade of pencil used, and with the type and texture of the paper (see opposite).

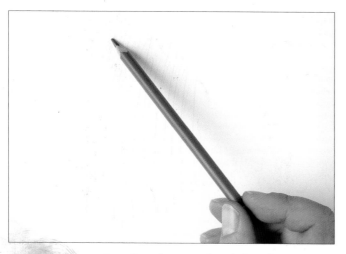

If you hold the pencil gently at the top and work from the wrist, you can create long, pale marks.

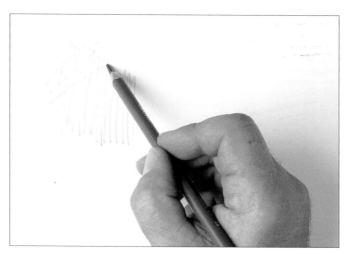

If you move your fingers further down the pencil and still work from the wrist, you can create shorter, darker marks.

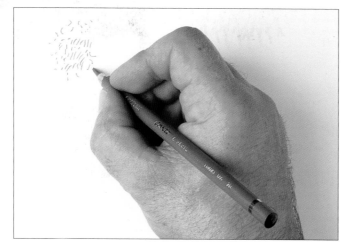

If you grip the pencil firmly close to its point and work from the knuckles, you can create very short and dark marks.

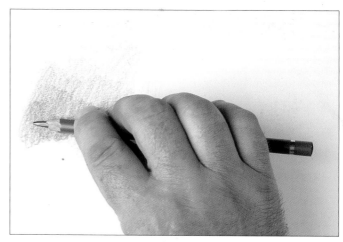

If you hold the pencil with the side of the lead touching the paper, you can make broad marks. Change tones by varying your grip on the pencil.

Watercolour paper Cartridge paper

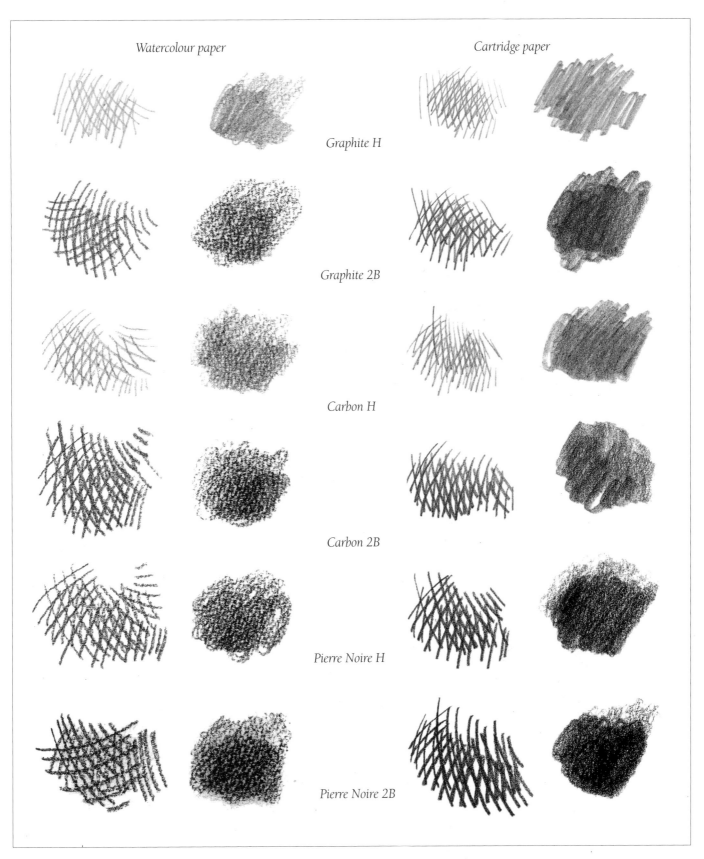

Graphite H

Graphite 2B

Carbon H

Carbon 2B

Pierre Noire H

Pierre Noire 2B

Try various pencils and papers and discover the differences in the quality of the marks you make. Here, six different pencils have been used to make crosshatching with the points, and shading with the side of the leads. The left-hand marks are made on watercolour paper, the right-hand ones on cartridge paper.

Tonal values

Try this exercise to develop your awareness of tonal values between the extremes of pale and dark. For this example, I used a 2B graphite pencil on a sheet of cartridge paper.

1. Hold the pencil gently at the top. Move from the wrist and shade very lightly. Try using the side of the pencil lead (left-hand column) and then its point (right-hand column).

2. Now hold the pencil in the same way and perform the same two actions as in step 1 but, this time, leave a little of the previous tonal value showing.

3–7. Continue to shade in this way from pale to dark. For each layer, gradually move your fingers closer to the pencil lead, allow your grip to become slightly firmer, and change the stroke movement from the wrist to the knuckles. Leave a little of the previous tonal value showing so that you create a tonal scale from pale to dark. Remember, one scale is made with the side of the lead and the other with its point.

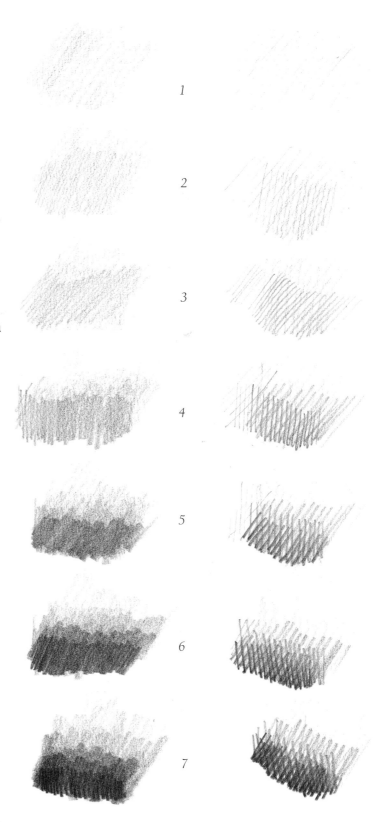

These marks, made with a 2B graphite pencil on cartridge paper, show seven layers of tone to create a gradual transition from dark to light. The left-hand marks were made with the side of the lead, the right-hand ones with its tip.

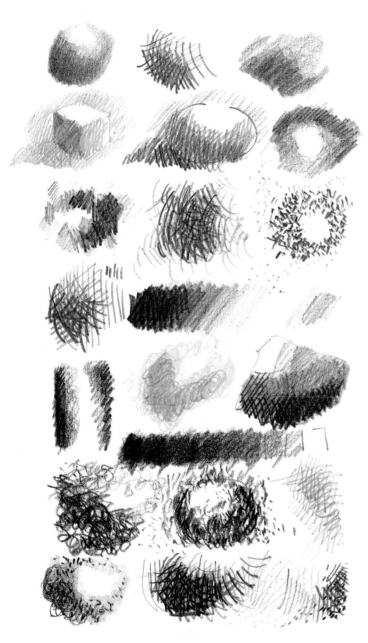

These marks were made using a variety of different types of pencils.

Tone and texture

Using as many kinds of graphite, carbon and Pierre Noire pencils as you can find, and working on different kinds of paper, develop the exercises on pages 15 and 16 to make lots of different marks.

Follow the method of making tonal values from pale to dark (see opposite). Try not to be inhibited with your marks and you will soon discover how to make a variety of effects.

When you have completed this exercise and begun to understand how to make the pencils work, you are ready to continue your adventure.

Composition

I must say a few words about composing pictures – about where to place your subject on the paper. There have been many rules and guidelines written about composition. The most favoured is to place the main feature slightly off centre; one-third in from the side of your paper, and in the top or bottom third of it. You, like many of us, will probably do this instinctively.

You must also be very much aware of the shapes you see in between the main features. These are equally important to the composition. Indeed, they are 'the powers behind the throne'!

Another important consideration is to choose a view where you see a contrast between light and dark tones and between colours. Whereas colours appeal to our emotions and are necessary to nurture our spirits, tonal values appeal to our minds and help us to make sense of things. When you are working indoors, try lighting your subject from various angles and note the different effects you can achieve.

Trees in a Landscape

Never in the world's history has there been a greater desire to escape from the technological realm of computers and electronic machines than at the present time. As we enter the new millennium we stand in greater need of the healing powers of nature than ever before. Therefore, let us turn to nature for our first subject and draw some trees dappled by the morning light.

You will need
Cartridge paper
Graphite pencils (2H to 3B)
Putty eraser
Viewfinder

1. Use the viewfinder (see page 11) to compose your picture. Then, lightly holding the top of a 2B pencil, start drawing the main contours in very pale and broken lines.

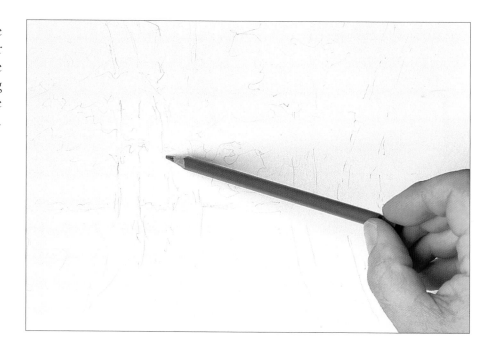

2. When all the main elements have been positioned, redefine these contours, correcting and amending them with similar pale and broken lines.

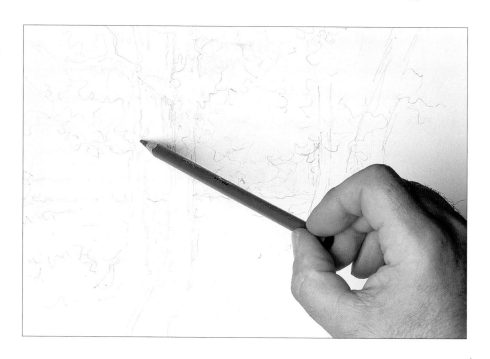

3. Now, holding the pencil nearer to its tip, use slightly more pressure to develop the contours even further. Remember that you are still in the process of finding your way around things, so do not expect to achieve absolute accuracy yet!

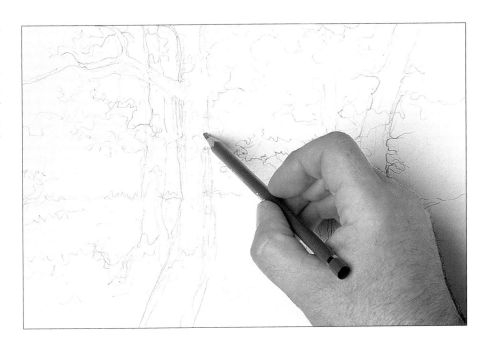

4. Half close your eyes then select and mark out all the palest areas in your composition. Still using the 2B pencil, shade all other areas of the drawing very lightly with the same very pale tone. Vary the strokes of the pencil so that they follow the rhythmic directions you see in the subject.

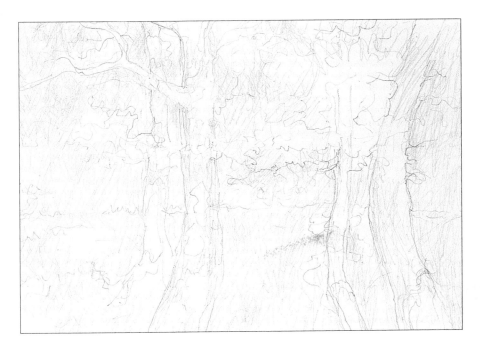

Note *Although you have been very careful, your drawing should look vague and seemingly imprecise. You have only just started to form its tonal structure, so it could be described as very young with plenty of scope for development.*

Do not be alarmed that your first layer of shading seems to hide your initial contours. It would be most unusual to have positioned all your contours correctly at this stage. You can accentuate those that are correct, and allow the others to merge with subsequent layers of shading. Drawing need not necessarily consist of putting lights and darks within already formed outlines; it can be a whole process of construction and reconstruction of light and dark areas by which lines can be formed and reformed to help us juxtapose such tonal values. After all, as Paul Cézanne said, 'Lines do not exist in Nature'.

5. Redefine your contours, again in broken lines, but using a 3B pencil to make marks slightly darker than your first layer of shading. Then, omitting the highlights and the lightest of the shadowed areas, shade the whole picture again with the 3B pencil, to create a tone slightly darker than that in step 4.

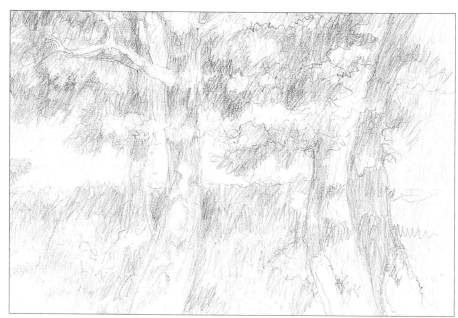

6. Still using the 3B pencil, redefine some of the contours that have merged into your previous layer of shading. Shade the whole picture a little darker, omitting the highlights and the lightest tones of the shadowed areas again, and also the not-quite-so-pale tones in these areas.

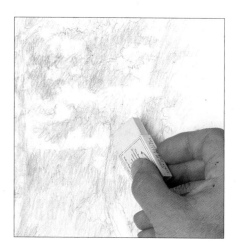

7. Use a putty eraser to identify those highlighted areas that you may have missed, or may have covered by the exuberance of your previous shading technique.

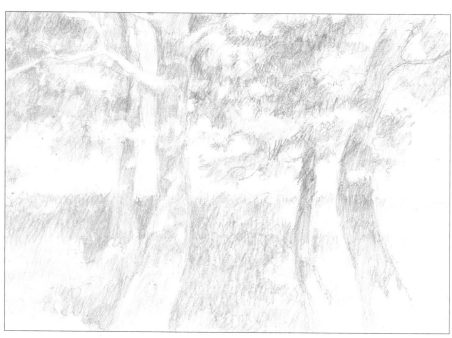

8. Now take a variety of pencils and use soft ones to identify the darker tones and hard ones to accentuate details. Use gentle touches to shade some pale and halftones which you may have missed earlier. Continue to use the putty eraser to reconstruct small highlights and reflected lights so that you achieve the effect of dappled light.

9. Continue to develop your drawing for as long as you like. Look back at each stage of this demonstration and notice that, although the drawing has never looked *finished*, it does look whole and complete at every step along the way. Remember what Paul Gardner said about a picture never being finished, 'It simply stops at interesting places'.

The finished drawing
297 x 210mm (11¾ x 8¼in)

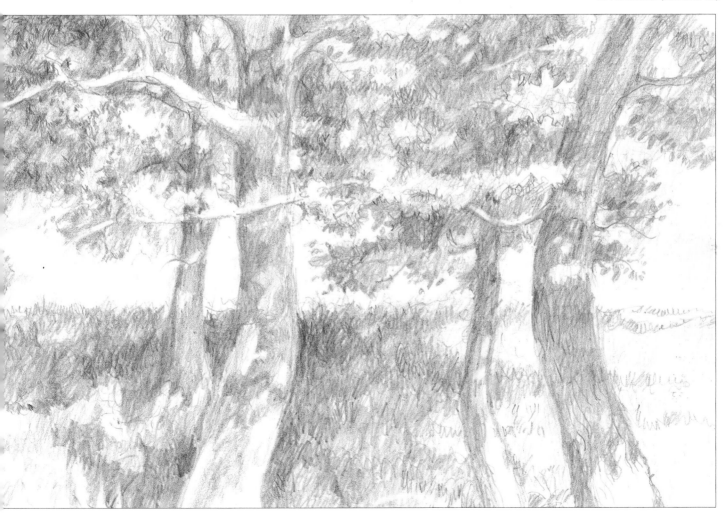

21

Charcoal and chalk

Now expand your repertoire and explore the properties of charcoal and chalk or white pastel. You will discover that they make more immediate marks than pencils. As before, assume the unprejudiced frankness of a child so that you may enjoy your adventures without impediments. As Stephen Nachmanovitch said, 'The most potent muse of all is our own inner child'.

Making marks

Use charcoal, in stick or pencil form, to practise making marks (as shown on this page) on a sheet of tinted pastel paper. Then use white chalk or white pastel to make similar marks. When you are happy with the basic strokes, develop them into different tones and textures similar to those shown opposite.

If you hold the charcoal stick at an angle you can create fine lines with its tip.

If you hold the side of the stick against the paper you can create broad strokes.

If you change the angle of the chalk you can create contours of varying thickness.

If you press the chalk firmly on the paper, you will notice its opaque nature.

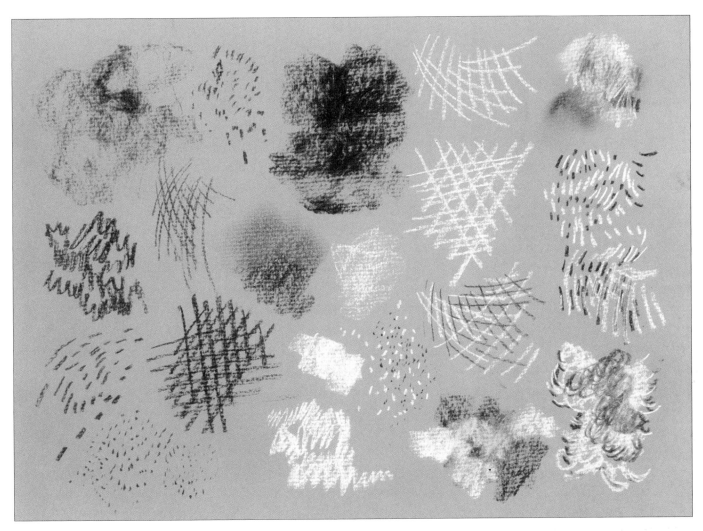

Charcoal and chalk can be used on their own or together to form a wide variety of marks.

Full-size detail from the above sheet of marks.

Tumbler and Fruit

Let us now draw a simple study in charcoal and chalk. We will employ the same principle of drawing as used for trees on pages 18–21, and gradually develop the composition as a whole from start to finish. However, this time we will be drawing on a grey pastel paper, so we shall start from a mid-toned grey and work towards the palest and darkest tones concurrently.

You will need
Grey pastel paper
White chalk or white pastel
Charcoal pencils B and 2B
Charcoal stick, medium thickness
Putty eraser

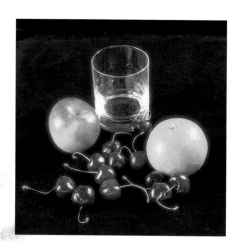

Photograph of the still life.

1. Use white chalk or white pastel (one tone paler than the paper) to draw the main contours in broken lines, and to gently mark in the highlights.

2. Hold the charcoal stick very lightly on its side and apply broad strokes (one tone darker than the paper) to the mid- and dark-toned areas of the composition. Use the tip to redefine some contours.

3. Continue to develop and darken the tonal values slightly and to define the contours. Make your marks following the contours of the images.

> **Note** *Allowing nothing to be either too light or too dark empowers you to make tonal corrections easily.*
>
> *Use the putty eraser to modify lines that are either too pale or too dark.*

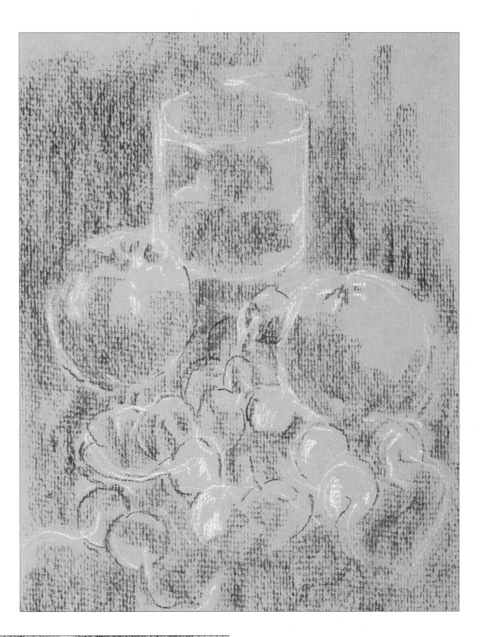

4. Use a B charcoal pencil to redefine the contours and start to develop the dark tones.

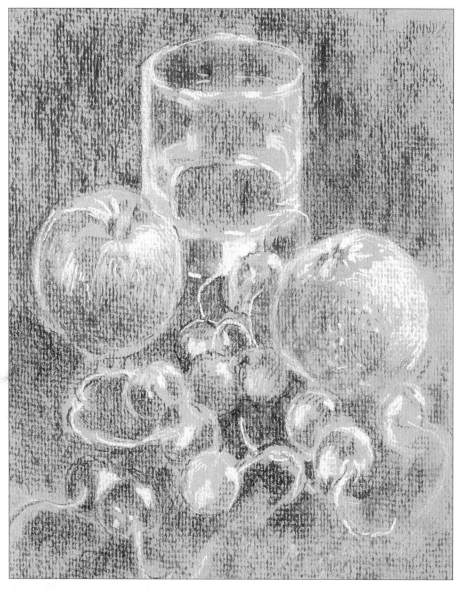

5. Use white chalk or white pastel to accentuate highlights and contours. Make adjustments to the composition if necessary – here, some of the cherry stalks have been erased and redrawn.

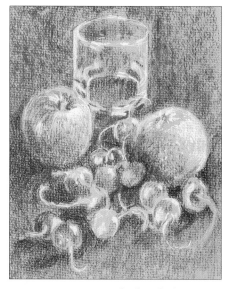

6. Begin to intensify the darkest areas using B and 2B charcoal pencils and the charcoal stick. Allow your strokes to follow the directions you see in the images.

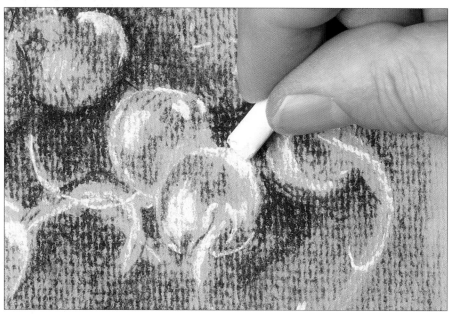

7. Now use white chalk or white pastel to develop the pale areas and the highlights in a similar way.

Opposite
The finished drawing
210 x 297mm (8¼ x 11¾in)

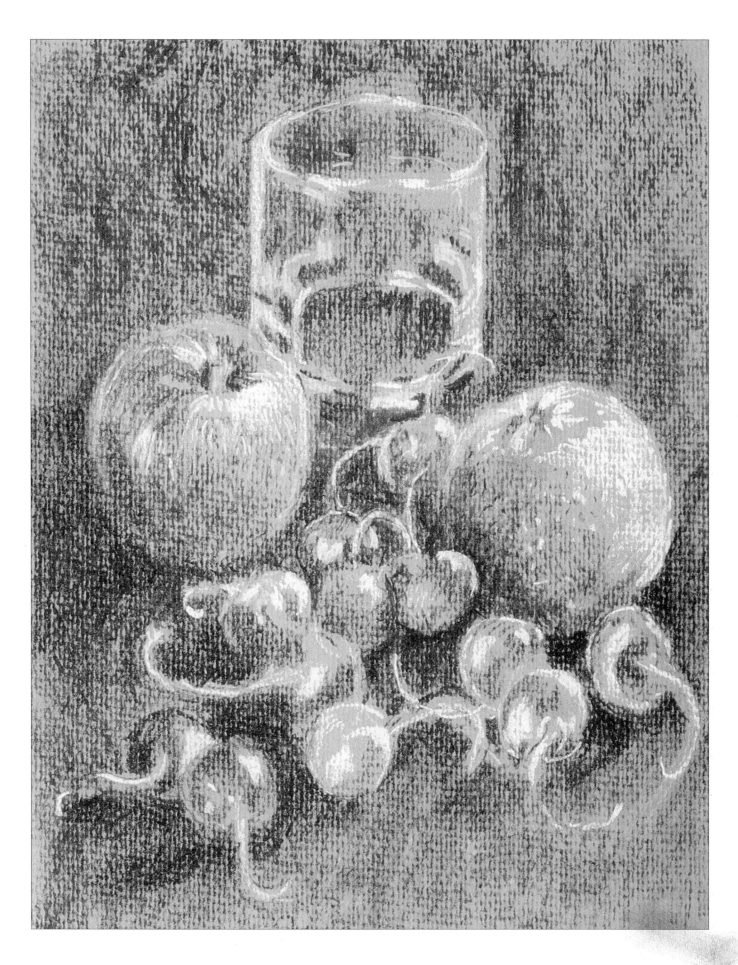

Coloured pencils

Now you are going to explore the wonderful world of colour. Practise the colour mixing exercises opposite to prepare yourself for some enjoyable adventures ahead.

If you use just the nine coloured pencils shown below (three hues of each of the three primary colours: red, yellow and blue) you will soon learn how to make an enormous variety of other colours including purples, oranges, greens, browns, greys and even blacks.

Mixing colours

Start your experiments by creating the colour wheel shown below. Purple, orange and green are known as secondary colours, and you will see that these have been made with specific primary colours in order to create the brightest possible hues. For example, you will notice that Dark Ultramarine and Cyclamen are closer to purple than the other blues and reds.

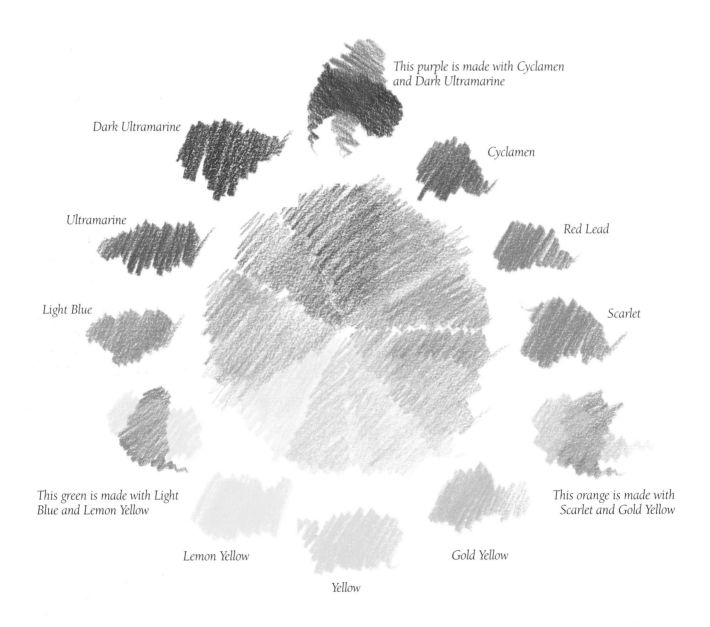

This purple is made with Cyclamen and Dark Ultramarine

Dark Ultramarine

Cyclamen

Ultramarine

Red Lead

Light Blue

Scarlet

This green is made with Light Blue and Lemon Yellow

This orange is made with Scarlet and Gold Yellow

Lemon Yellow

Gold Yellow

Yellow

Try mixing all pairs of colours and notice how the resulting hues of secondary colours vary from bright to dull. Here I show some hues of green that can be made by mixing the three yellows with the three blues.

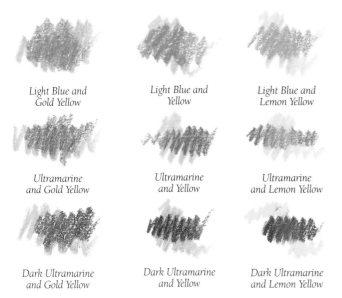

| Light Blue and Gold Yellow | Light Blue and Yellow | Light Blue and Lemon Yellow |

| Ultramarine and Gold Yellow | Ultramarine and Yellow | Ultramarine and Lemon Yellow |

| Dark Ultramarine and Gold Yellow | Dark Ultramarine and Yellow | Dark Ultramarine and Lemon Yellow |

Now try mixing pairs of colours in various proportions to make even more hues. Start with the mixtures for the brightest secondary colours – here are three examples of bright orange hues made from Gold Yellow and Scarlet. Also try varying the mixes for bright greens (Lemon Yellow and Light Blue) and bright purples (Cyclamen and Dark Ultramarine).

Bright oranges: Gold Yellow and Scarlet

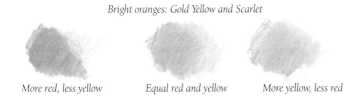

More red, less yellow *Equal red and yellow* *More yellow, less red*

Next practise making the dull greens, oranges and purples. These can be varied so much that some appear more brown or grey, because a vestige of the third primary colour is present in each pair of colours. For example, in the dull purples below, Light Blue and Scarlet both contain traces of yellow.

Dull purples: Scarlet and Light Blue

More red, less blue *Equal red and blue* *More blue, less red*

Browns, greys and even blacks can be made by mixing the three primary colours together. Reddish browns have more red, yellowish browns have more yellow, and greys (bluish browns) have more blue. The darker the greys, the more they seem like black. Under these examples is a colour code showing the greater and lesser amount (by your pressure on the pencil) of the particular colours used.

Cyclamen, Gold Yellow and Dark Ultramarine

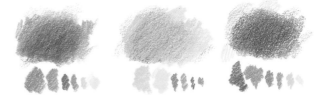

You can also make other browns, greys and blacks by mixing various hues of primary colours.

Red Lead, Scarlet, Ultramarine, Light Blue, Yellow and Lemon Yellow

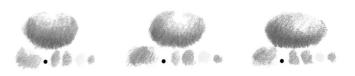

Notice that browns, greys and blacks are biased towards one or other of the primary and secondary colours, and this is also true in nature. Furthermore, you can apply such mixtures to primary and secondary coloured objects where they are dark, dull or in shadow. The examples below show how the three reds can be adjusted in this way. The colour *before* the point (•) is used all over the shape, lightly or firmly, as appropriate, to render light and shadow. The colours *after* the point are used only in the duller and darker areas, leaving the rest bright and pale.

Explore and extend these colour exercises as much as you like. The more you do, the more you will facilitate your understanding of the nature of colour mixing and how you can apply it to drawing.

Variegated Ivy (greens)
230 x 150mm (9 x 6in)

Coloured pencils on cartridge paper.

All the coloured drawings illustrated on these two pages follow the same principles of colour mixing which we explored on the previous page.

Adjacent to each drawing are colour codes showing the greater and lesser amount of each colour used. The primary and secondary colours shown before the point are used throughout each feature; those following the point are used only in the dark and dull areas. However, for the greys in Nanny Goat and the browns in Plums all colours are used throughout the appropriate areas.

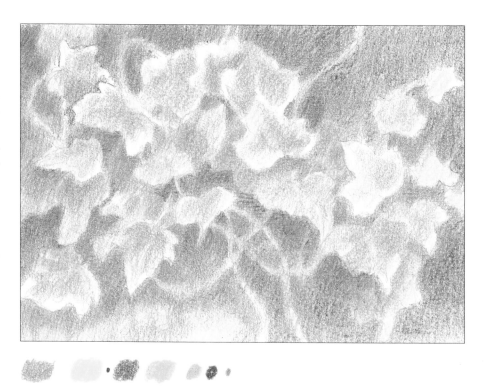

Nanny Goat (greys)
200 x 200mm (8 x 8in)

Coloured pencils on cartridge paper.

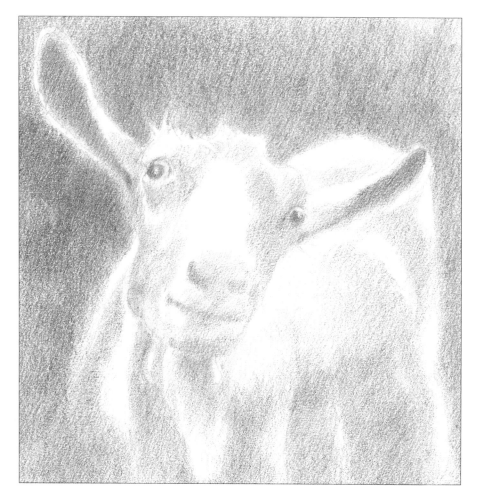

30

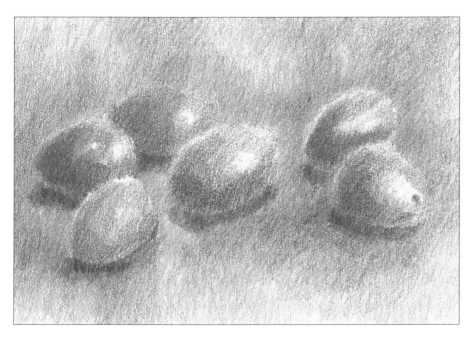

Plums (purples and browns)
210 x 135mm (8¼ x 5¼in)
Coloured pencils on cartridge paper.

Purple fruit

Brown table

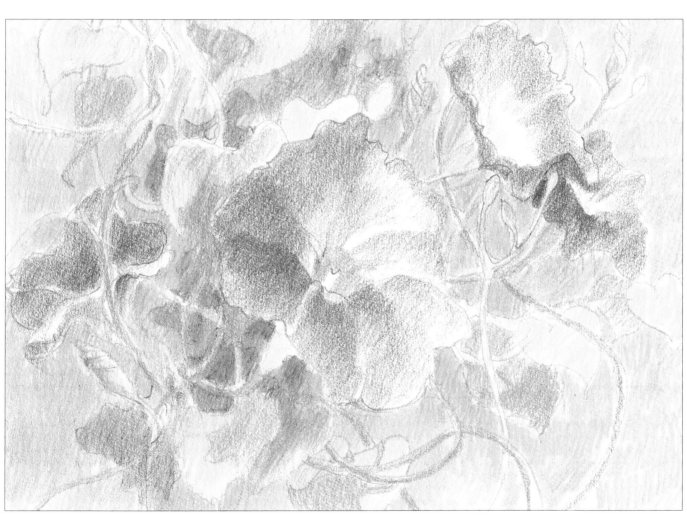

Morning Glories (blues, greens and oranges)
297 x 210mm (11¾ x 8¼in)
Coloured pencils on cartridge paper.

Blue flowers *Green leaves* *Orange wall*

Herbaceous Border

Goethe said, 'Flowers are the beautiful hieroglyphics of nature by which she indicates how much she loves us'. Most of us love flowers so let us reciprocate our mutual feelings with nature and devote our attentions to these 'beautiful hieroglyphics' with our coloured pencils.

My preference is to start and complete a drawing directly from nature. However, it is also possible to work a finished drawing from a detailed sketch and photographs for colour reference, which is how I composed this picture.

You will need

White cartridge paper

Putty eraser

Coloured pencils: Scarlet, Red Lead, Cyclamen, Lemon Yellow, Yellow, Gold Yellow, Light Blue, Ultramarine, Dark Ultramarine

Reference photographs and field sketch.

1. Use the three reds and three yellows to draw the contours of the main elements of the composition very lightly. Hold the pencils gently so that your marks are extremely pale.

2. Now use the three blues to develop all of the main contours of your composition.

Note *Although a putty eraser is generally used with graphite/ carbon pencils, it is also possible to erase very pale marks made with coloured pencils.*

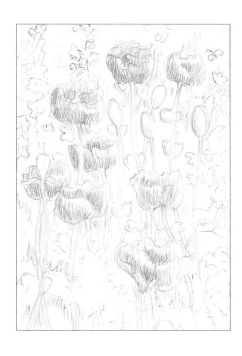

3. Use all three reds to shade the poppies gently and lightly. Leave the white of the paper to indicate their highlights. Include some pale red marks in dark, dull areas of the background.

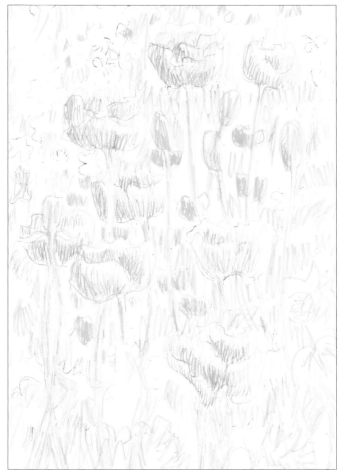

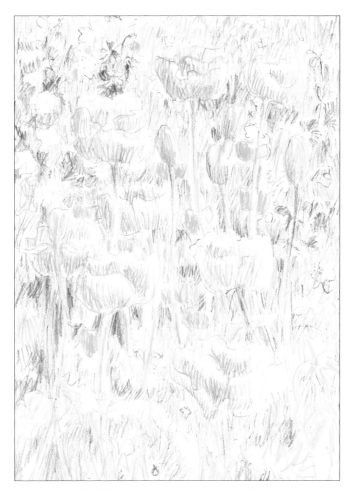

4. Now use all the yellows. Colour the buttercups and the shadowed areas of the poppies and background with Yellow and Gold Yellow. Colour the stems and leaves with Lemon Yellow.

5. Use all the blues in the same way. Colour and shade the delphiniums and all shadowed areas with Ultramarine and Dark Ultramarine. Develop the green stems and leaves with Light Blue.

6. Return to the three reds and continue to develop the poppies with slightly more pressure. Also use them lightly in all dark, dull and shadowed areas throughout your composition.

7. Return to the three yellows and use them to develop appropriate areas.

8. Finally, return to the three blues and perform similar actions as steps 6 and 7, in appropriate areas of the picture so that you develop the composition as a unified whole.

Opposite
The finished picture
210 x 297mm (8¼ x 11¾in)

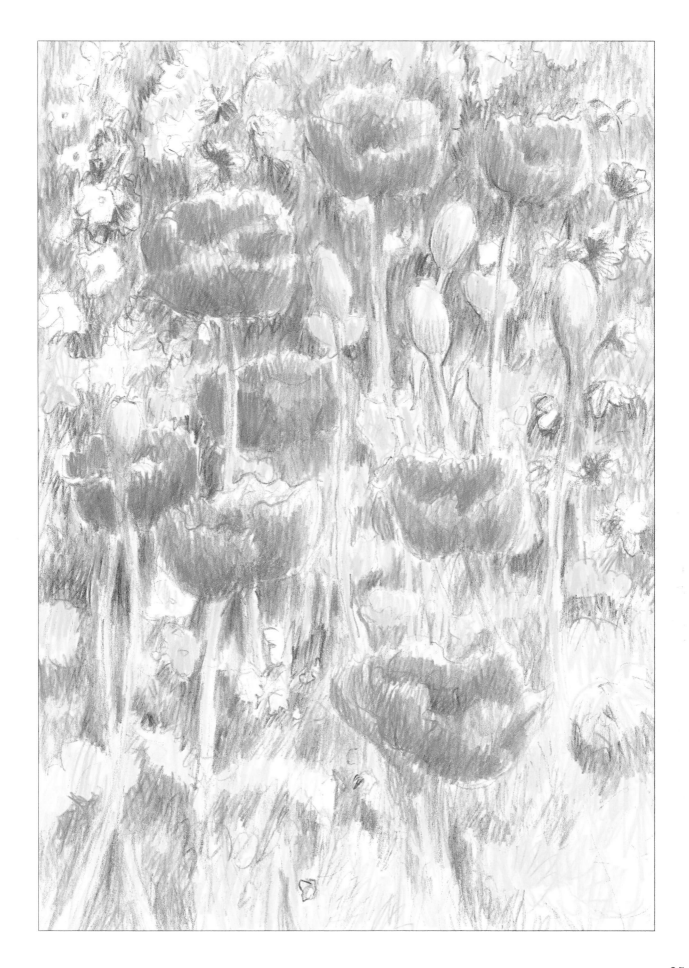

Pastels and Conté crayons

Now that you have experienced coloured pencils, you are ready to explore pastels and Conté crayons. They both have powdery and opaque qualities similar to those of chalk and charcoal. A variety of colours can be made by mixing them on the paper; it is for this reason that we now need to introduce white. Try overlaying the colours so that you can see how they cover what you have drawn underneath. Such excellent 'hiding' properties are much to our advantage.

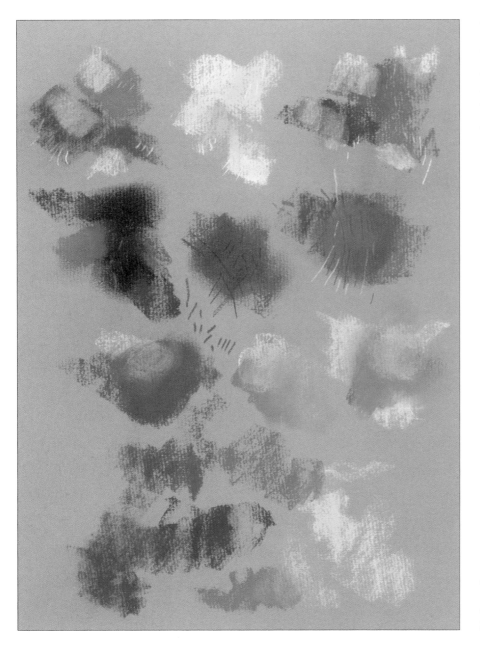

Making marks

Play with the pastels. Make different marks, experiment with colour mixing and discover how pastels behave compared with the other media you have been using.

The same nine colours shown on page 28 are also available as soft pastels and Conté crayons. Practise making marks and mixing them on a sheet of pastel paper, occasionally introducing white.

Lemon, Peppers and Tomatoes

When you practise making marks with pastels you will discover for yourself that pastels are rather different from coloured pencils but similar to charcoal and chalk. So let us take another still life as our subject for a demonstration. Remember that you can create colours and tones by *mixing* rather than *overlaying* one over another. Nevertheless, the *principle* of creating colours and tones is the same as that described on pages 28–29.

You will need

Pale yellow pastel paper

Stick pastels: Scarlet, Red Lead, Cyclamen, Lemon Yellow, Yellow, Gold Yellow, Light Blue, Ultramarine, Dark Ultramarine, White

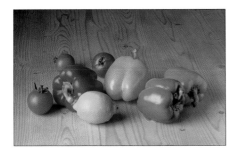

Photograph of the still life.

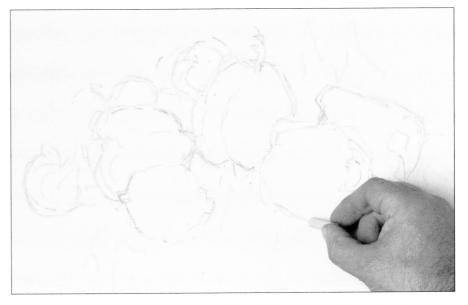

1. Lightly draw the main contours of the whole composition using the tip of the Scarlet pastel. Correct and develop the contours with Light Blue and Yellow.

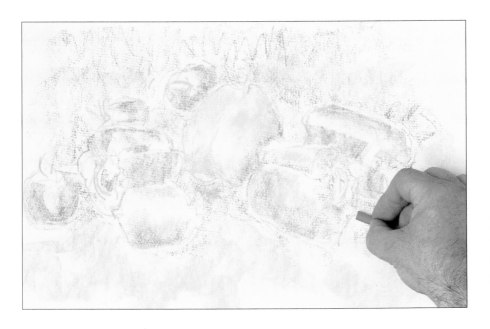

2. Use the side of the same three pastels to indicate the colours in the shadowed areas. If necessary, add more edge strokes to accentuate outlines.

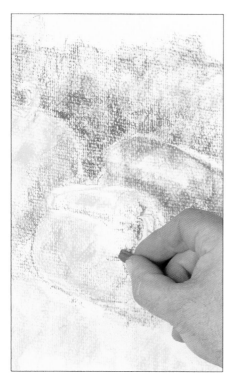
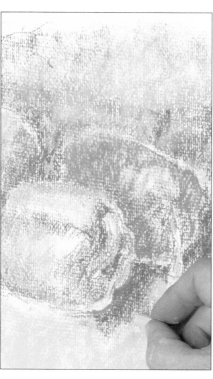

3. Use the other two reds, blues and yellows to develop the colours and tones of all features in the composition.

4. Continue to develop the picture with all nine colours and white. Use more pressure to blend and merge colours in certain areas.

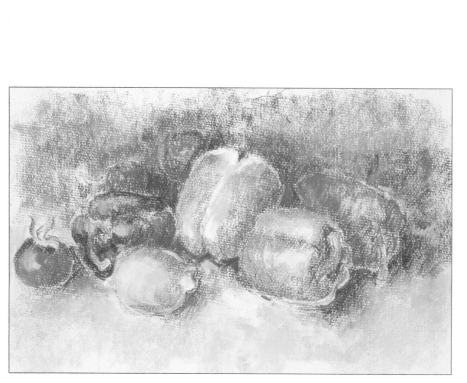

5. Darken shadows with the dark-toned pastels. Finally, accentuate highlights with pale-toned and white pastels.

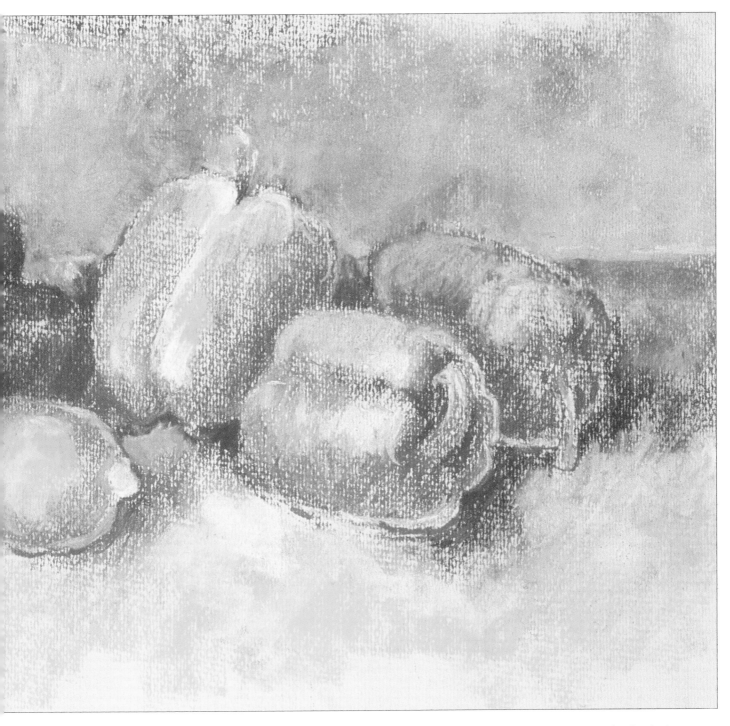

The finished painting
420 x 297mm (16½ x 11¾in)

Notice that the 'levitating' tomato has been removed from behind the yellow pepper. I also lightened and smoothed the background to provide more contrast with the foreground images. The excellent hiding or covering power of pastels can obliterate unwanted features at any time, even at this late stage.

DRAWING LANDSCAPES

by Ronald Swanwick

The foundation for all artistic endeavour is, without doubt, drawing. I first developed a passion for drawing at the age of eleven, and in the forty years which have passed since it has never diminished. I paint in and teach oils, acrylics and watercolour and believe my best works come from my drawings and sketches. During the process of drawing or sketching you observe and soak up the atmosphere, and can sort out the composition and tonal values which are the most important parts of a painting. Colour, which is subjective, can be formulated in the studio. However, photographs can be extremely useful, especially when you are short of time.

In this section I will share some of my approaches to drawing landscapes. These may vary according to time constraints, the subject matter, weather conditions or whether I see the work as an end in itself or a preparation for a later painting. My personal definition of drawing is a work brought to completion with accurate and careful note of all the textural and tonal values, whereas a sketch is as succinct as possible and contains my own form of shorthand to prompt my memory.

You will see that I have recorded the time taken for many of the finished pictures in this section, because I believe speed is a vital ingredient in a good drawing or sketch. A sense of urgency adds fluency to your marks which will lead to a much more pleasing finish. I hope the following pages will inspire you to go out and use a pencil at least as often as a brush.

Composition

Composition is a core ingredient in the creation of every successful drawing or painting. If you fail to achieve a good composition, your picture will be less successful even if your technique is superb.

If you are taking photographs to work from (see page 51), think about composition by asking yourself what story you want to tell. Always take several shots from a range of angles. Remember that your camera will only take an average light reading, so take close-ups of any dark areas, especially on very sunny days. If you particularly want strong shadows in your composition, take photographs either early in the morning or in the evening when the sun is low. This will give your shots far more contrast, which is especially important for snow scenes.

Old cart

In the garden of my studio is a rather dilapidated horse-drawn cart. The examples show how I used different views of the cart and its surroundings to plan my final drawing.

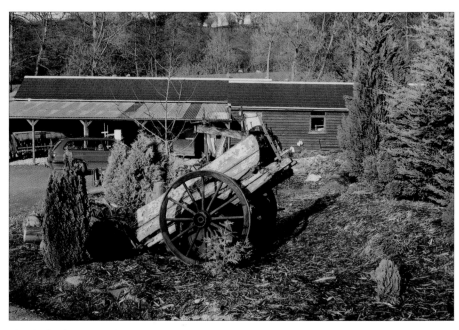

This is the first view of the cart as you come down the drive. The composition from this viewpoint has little to commend it; the cart is in the middle of the frame and the roof line of the buildings chops the picture neatly in two. Despite the fact that the cart is the intended subject, I find that my eye is inexorably drawn to the red car in the background.

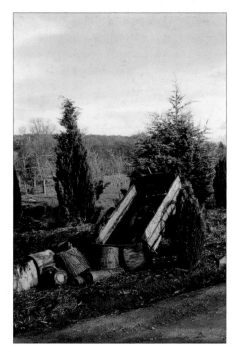

This shot in portrait format and at a different angle gives a better backdrop, but the composition is a little awkward, even though there is an interesting shadow of the wheel on the side of the cart. The two spaces on either side of the conifer on the left makes the arrangement feel a little regimented. Making the conifer bigger and moving it to the left is one possibility, but I would still look for a better option.

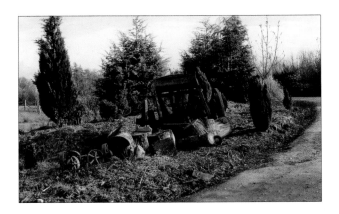

For this shot, I have moved further to the left and changed to landscape format. I much prefer the curve of the edge of the drive, but the head-on view of the cart is not very attractive. The way in which the lines of the cart coincide with the slight lean of the trees gives the composition a definite list to the left.

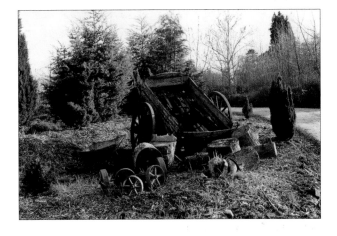

I have finally settled for a shot taken from a little further to the left and slightly nearer to the cart. Although the cart is more or less in the middle, I feel that, with a few slight modifications, this will produce the best composition.

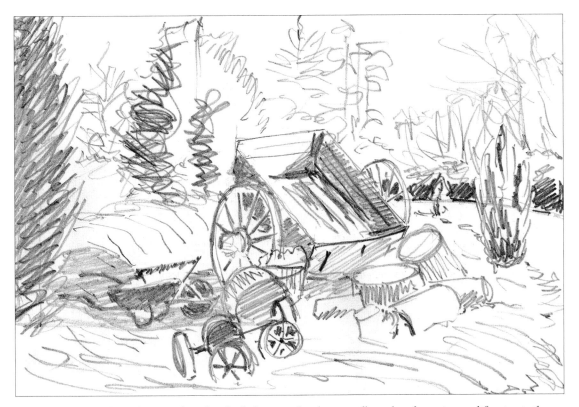

If you compare the last photograph to this final planning sketch, you will see that the major modification is the large, dark shape of the conifer on the left. The conifer from the centre of the photograph has moved slightly to the right, which increases the space between the conifers and creates a greater sense of depth. The dark conifer in the top right background of the photograph has been eliminated, further accentuating the feeling of space. I have also paid attention to the composition of the shadows, as these play a very important part in the creation of a successful composition.

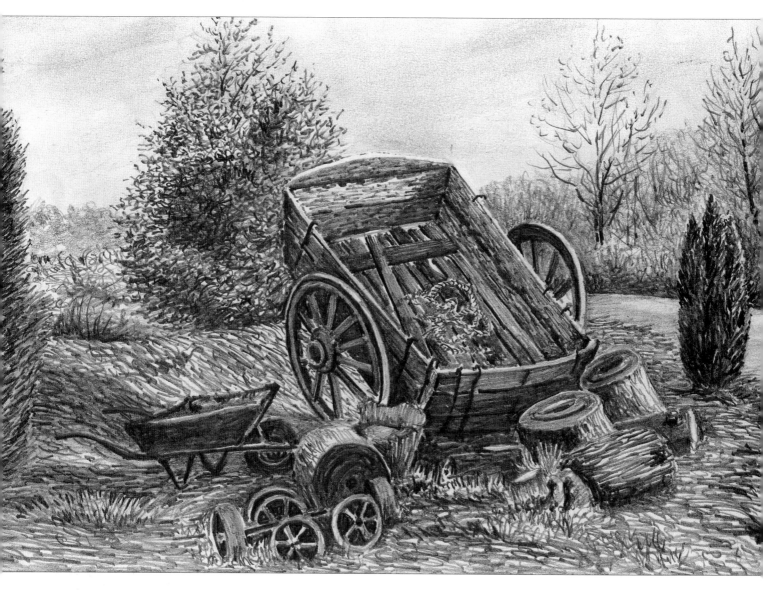

The finished drawing

If you compare the finished drawing to the plan on the previous page, you will see that there is a further modification: I have matched the left wheel to the right to make them appear to be attached correctly to the cart. In fact, the wheels are simply lying against it until I find the time to take off the modern rubber wheels and fix the original wooden ones back on.

An important point to remember when planning a composition is that you are making a drawing or painting for its own sake: you do not have to record exactly what is there. Feel free to move things and experiment with planning sketches.

Time taken: 2 hours

Cider press

This rare example of a travelling cider press is also in my studio garden. I hope to restore it one day, but even in its dilapidated state it is an interesting subject.

The press is in a corner of the garden which is being used to store building materials. It is impossible to take a photograph which will make a good composition, so some ingenuity is required to create a pleasing picture. The sketches below show how I have manoeuvred the scale and position of the press, and removed undesirable items from the view. All three plans are acceptable, but I prefer plan C because it feels more comfortable and seems to have a little more breathing space.

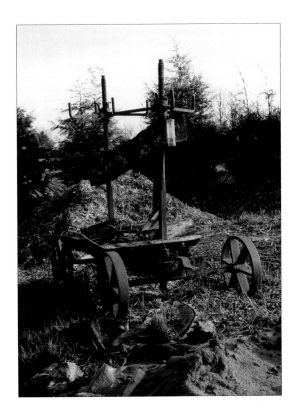

The photograph. First I want to deal with what I call the 'unfortunate coincidences': the top of the trees is in line with the top of the press, and the top of the pile of wood chippings is in line with the beam of the press.

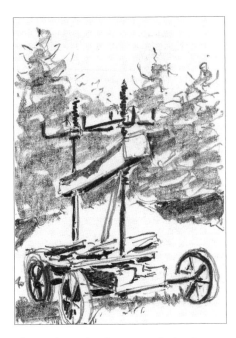

Plan A shows that by raising the height of the trees I am able to create a strong contrast with the winding gear, and give the impression that the press is bathed in light.

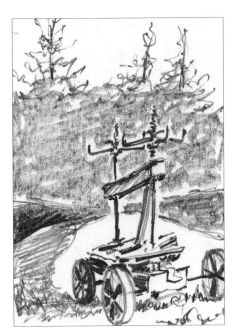

In plan B, the press has been reduced in size and moved to the right. The height of the pile of chippings has been lowered, which presents a less confusing conjunction of lines.

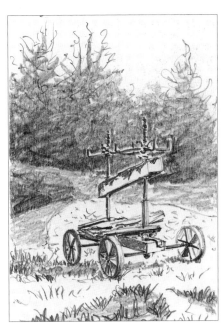

Plan C is the option I prefer. I like this composition because it allows me to use strong contrasts of light against the conifers, giving the effect of 'lifting' the machine off the background.

These farm buildings are on a sloping site, so the rising angle of the yard will not vanish to the same point as the lines on the building, and the two elements should be treated separately.

eye level

eye level

In this example, the eye level is almost at the bottom of the wall at the nearest corner, so the lines of perspective on the building all descend. Take care not to confuse the line of the kerb with the perspective of the building: the gradient of the road means it has a different vanishing point.

eye level

In this example the eye level is at the bottom of the building, so all the lines of perspective descend, away from you, to a vanishing point off the photograph to the left. Notice also the steep descent of the roof, which goes to the same vanishing point on the right as the underside of the lean-to roof.

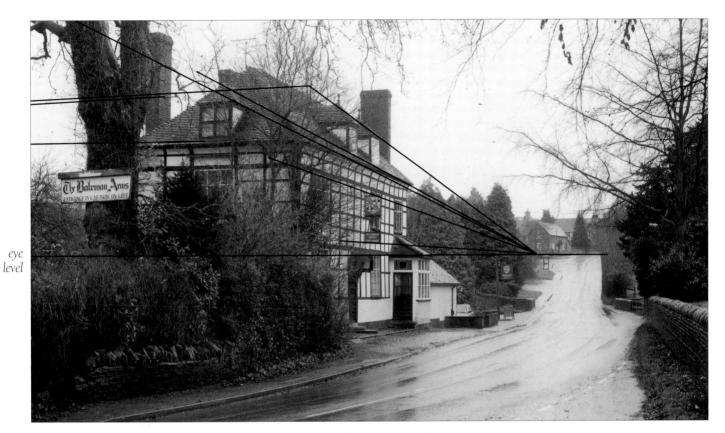

eye
level

This photograph shows how your eye level can be found where the lines on both sides
of a corner are horizontal. One vanishing point is on the right of the photograph, just
above the gap in the wall, while another is way off the photograph to the left.

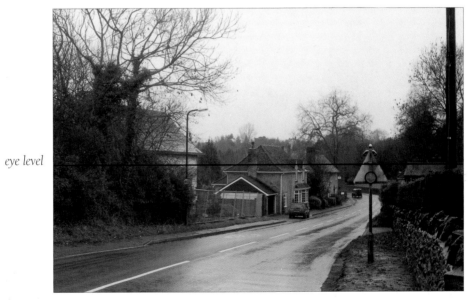

eye level

In this photograph, the lines of perspective are very subtle but it is still important that
you angle them correctly. Again, the road is sloping so its vanishing point is not on
your eye level.

Sunshine and shadows

The shadow areas in a picture are very important, and my maxim is: don't be afraid of the dark. The only way to achieve the effect of light in your drawing is to put on shadows which are sufficiently dark.

The main point to remember about cast shadows is that the textures in the shadow area must be the same as in the light area: it is only the tonal value which is darker in the shadow. Leaving out white spaces will give your drawing extra sparkle – as long as they are small! If they are too big, they will simply look as though you have missed bits out. The ivy leaves on the trees in the drawing below are an example of how effective this technique can be if used carefully.

> **Note** *Always put in the shadow areas before adding any texture.*

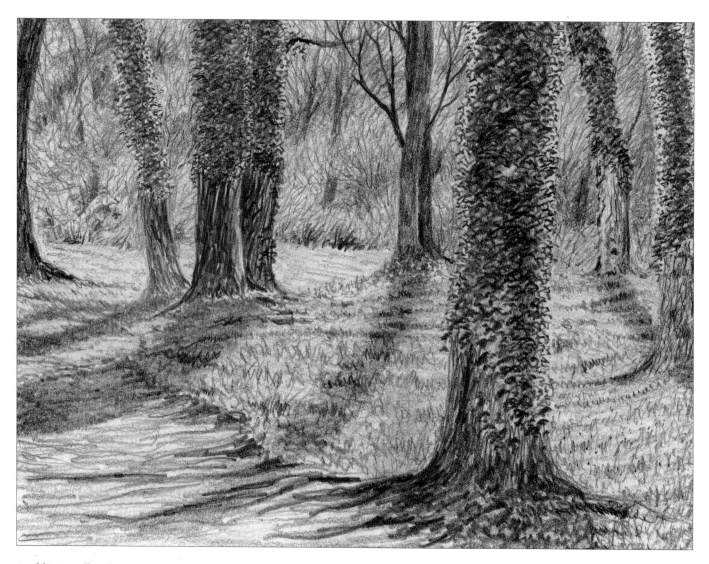

Backlit Woodland
Time taken: 3½ hours

Working with photography

When taking photographs on a sunny day, the lightest and darkest areas will inevitably suffer from under- and over-exposure. This photograph of a seed drill in an open shelter has not picked up detail at the back of the shelter, which you would be able to see. The stones appear far brighter than they would to the eye.

There are different ways to overcome this problem. If you have a manual camera, you can take extra shots at least two stops either side of the correct exposure. For both automatic and manual cameras, it is a good idea to move in closer and take shots of the interior with the correct exposures. This will help you to decipher the details when you plan your drawing.

Things are slightly more difficult if you are using a photograph which does not show enough detail, but which you did not take yourself. In this case, the best solution is to fill in what you think should be there. You cannot produce a successful drawing by filling in 'black holes' without any suggestion of texture.

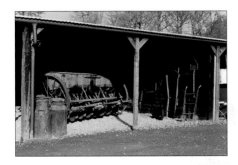
Under-exposed

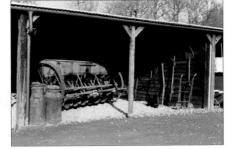
Correct exposure

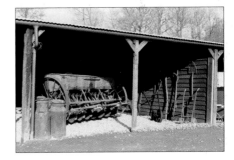
Over-exposed

Detail of interior

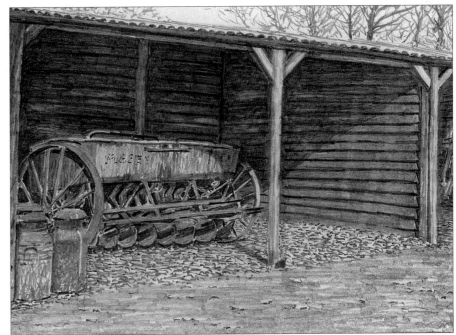

The finished drawing
Massey Ferguson seed drill c.1959
Time taken: 3 hours

Skies

The sky will set the mood or atmosphere of any picture. In most drawings of landscape, I suggest that you should include some clouds. A simple way to do this is to use a putty eraser as a drawing implement. First, put on a wash over the whole surface using a soft pencil, because these will smudge more easily. Then rub the pencil in well to eliminate any lines, using a circular movement. Crossing your fingers (see photograph A, right) will help to give extra pressure, but this is not obligatory! When you want a pale sky, use a soft pencil but do not press too hard.

Take a putty eraser and knead it into the shape you want, then use it to remove the pencil so that the white paper behind is revealed in the shape of the clouds (see photograph B, right).

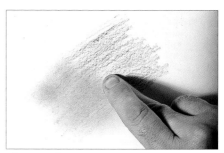

Photograph A

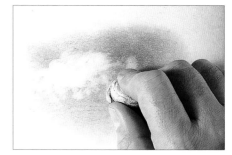

Photograph B

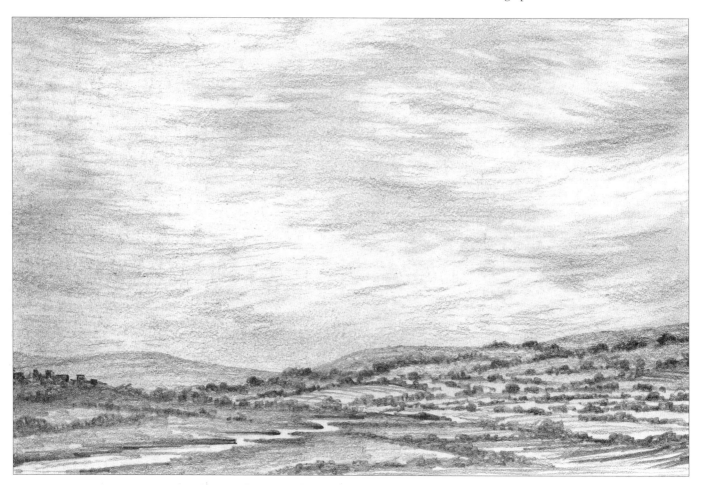

Cirrus Clouds

I have made this picture mostly sky, which always gives a tremendous feeling of space. The high cirrus clouds with their descending pattern enhance the sense of depth. The sky is simply a wash of grey, with the pattern of clouds lifted out using a putty eraser.

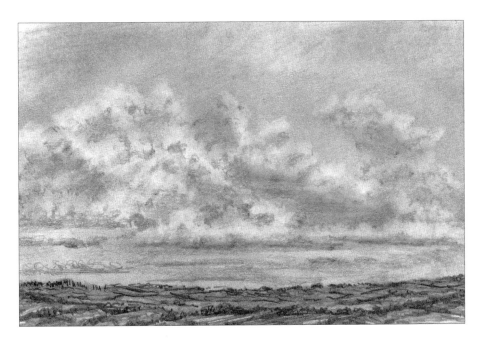

Cumulus Clouds

Note the fact that clouds like these are flat-bottomed, and the top of the clouds furthest away are chopped off by the bottom of the nearer cloud. Done well, this gives a good sense of distance in your landscape.

For the nearer cloud, I smudged in a grey wash all over, then lifted out the clouds with a putty eraser and added the shadows to give them some shape.

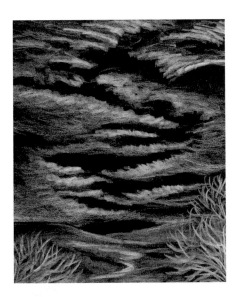

Moonlight Sky

This drawing is with a white pencil on a piece of black mount board. Try experimenting with different dark colours of board. You might also try using a limited range of sepia or earth colours for a night scene, which I find works very well.

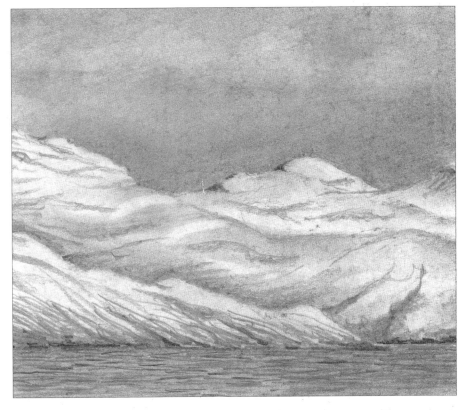

Grey Sky Over Mountains

If you use a good quality coated board for a snow scene, you can put in a grey wash all over the paper and lift out all the white areas with a putty eraser. Note that, if you want the sun to shine, you must create a very sharp edge against the sky.

53

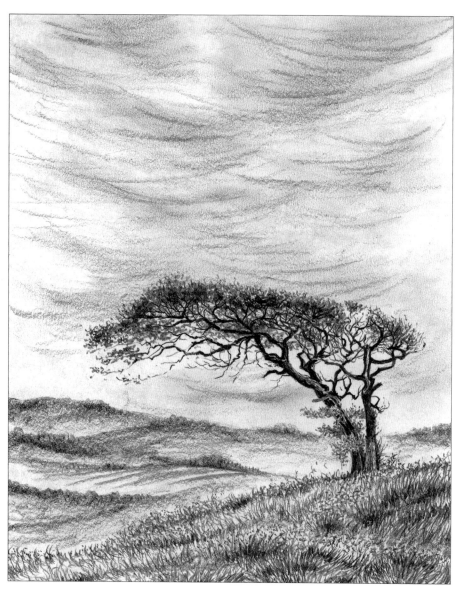

Windy sky

I came across this wind-blasted tree beside a main road on a sunny day. In this composition in HB pencil on cartridge paper, I have chosen to set it in an open field, and have given the sky a windy look to complete the story.

Time taken: 2 hours

Opposite
Hillside Farm

This drawing is in coloured pencil on pastel paper, a technique which gives a very soft finish. It is difficult to produce strong contrasts, particularly as I do not use black. I would use the same technique in shades of grey for soft winter, or in shades of reds and golds for autumn, but it is important to keep it subtle and not to use too many colours.

Time taken: 3 hours

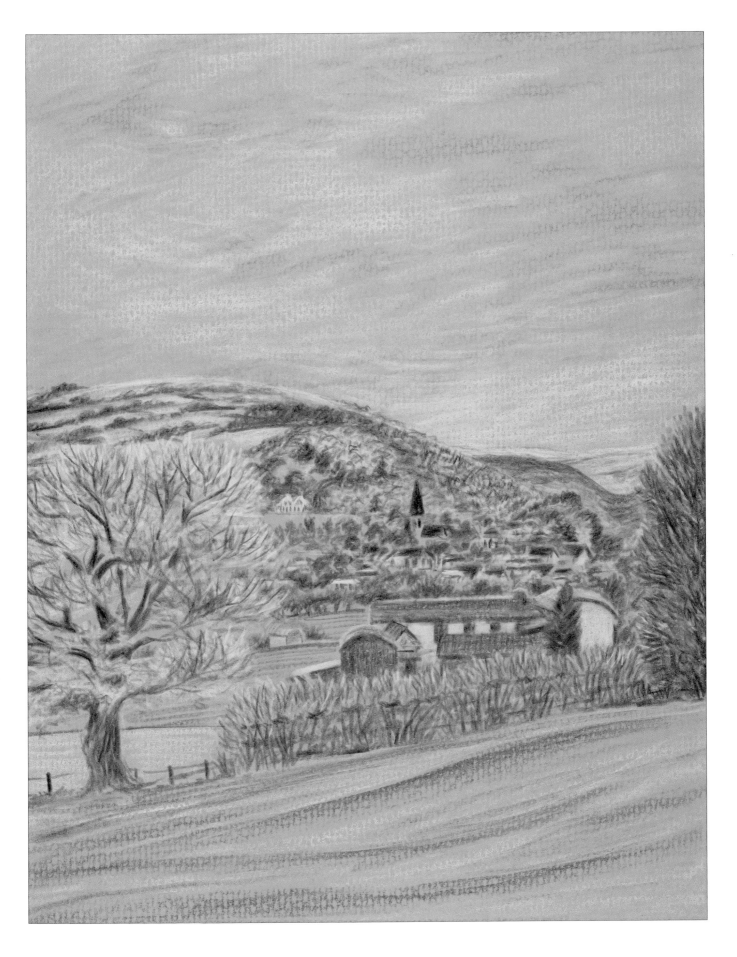

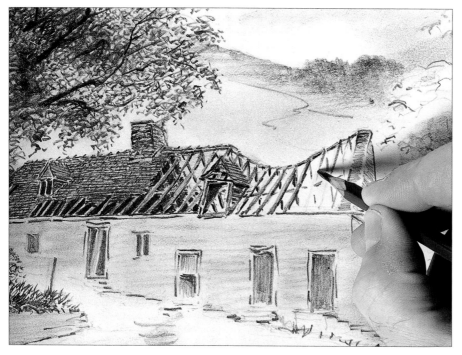

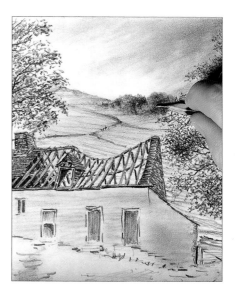

7. Complete the details of the rafters and the sections of roof tiles.

8. Complete the tree on the right using the scribble technique, then accent the clump of trees on the hill to create a highlight on the left of the tree in the foreground. Define the fields.

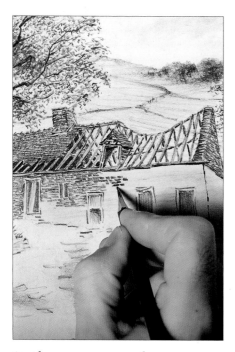

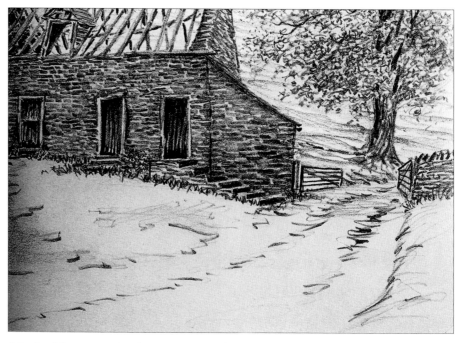

9. Sharpen your pencil to create a chisel point, so you can complete the stonework using one stroke of the pencil for each stone.

10. Building up a rhythm as you work and still using one stroke of the pencil for each stone, complete the stonework on the building and wall. Sharpen up the detail on the gate and darken the risers on the steps, leaving highlights on the edge of the treads.

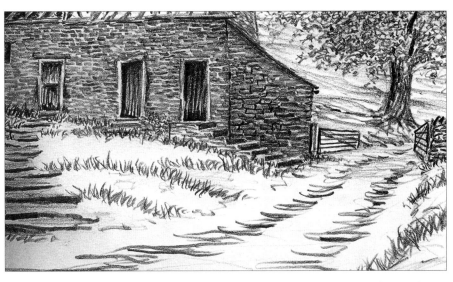

11. Work over your picture and add more fine detail, including the foreground pile of wood.

12. Put in a few lines to describe the contours of the banks and the track. Finish with marks to describe the grass, and horizontal marks of differing tonal values for the track.

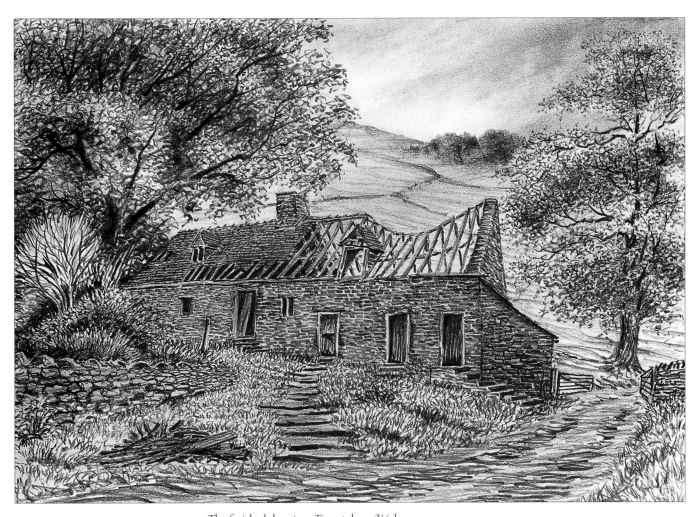

The finished drawing. Time taken: 3½ hours

Water

The general rule when you are drawing water is that all the marks are fundamentally horizontal because water is flat! It is only when you are working on an area of moving water – as in a close-up of a stream or falling water – that this rule does not apply.

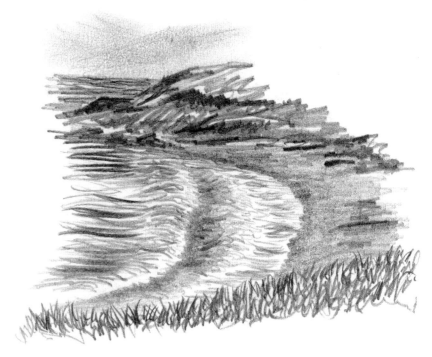

In this beach scene the curved appearance of the waves is created by placing horizontal marks in a curved pattern.

Whatever their size or shape, ripples always have pointed ends.

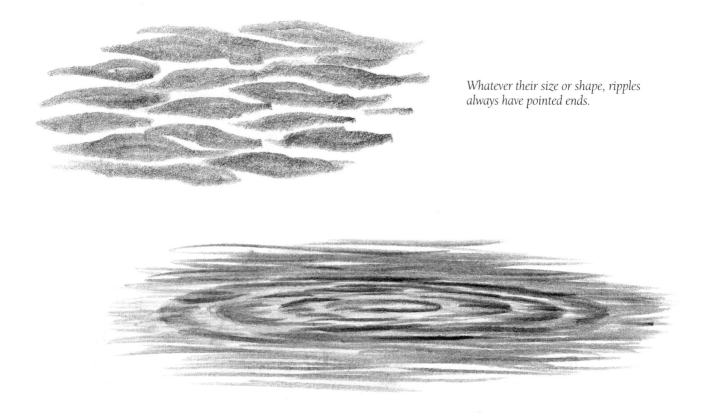

The ellipse effect – a series of horizontal marks placed in an elliptical pattern – is used to create a ring of ripples, or perhaps the bow wave of a boat. Note the short, fat marks at the sides and the long, thin marks at the bottom.

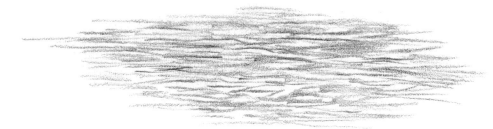

This effect was produced by laying down a wash and smoothing it with my finger, then lifting out the highlights with a putty eraser. Finish by adding a few darker marks to create shadows on the ripples.

When an object protrudes from the surface of still water, the division between the water and the object will be virtually horizontal. If the water is moving, however, there will be a curve or dip to the line.

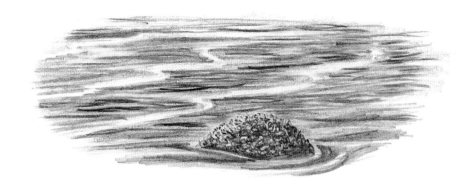

Reflections

When drawing reflections, remember that the water acts like a mirror so reflections are basically a mirror image. In most cases, reflections are illustrated by making ripple-shaped marks with a darker tonal value, and there is a certain amount of distortion because of the movement of the water.

Where the water is completely still, a different approach is required. In this case, the reflection is drawn with the same marks as the subject to create a perfect mirror image. Horizontal patterns are then lifted out, using a putty eraser, to produce the effect of a surface on the water. In a photograph, or even when you are looking at the scene, these marks may not be there – but if you do not put them in, your work will not look right. This is a good illustration of the fact that what you can accept in a photograph can sometimes look odd in a drawing or painting.

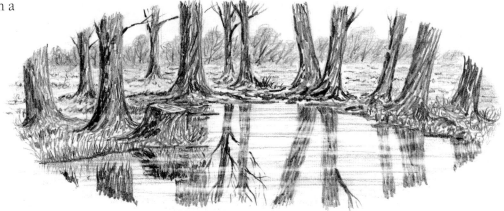

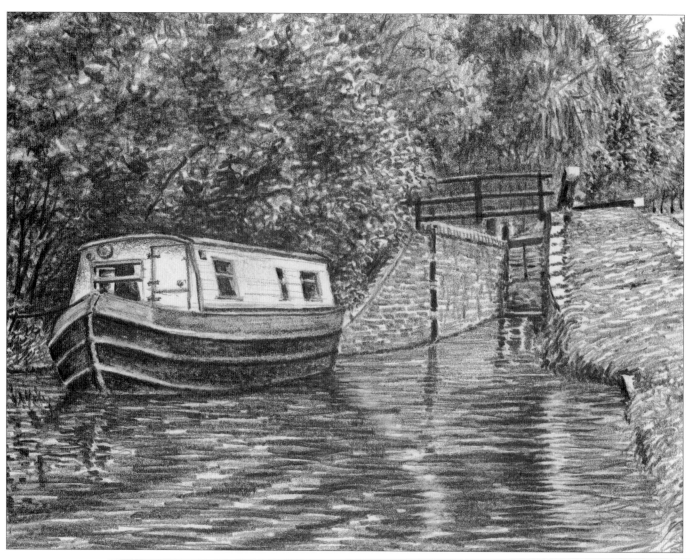

Canal Barge

An important point to remember about reflections is that the marks describing the water are all horizontal. Even if the reflection is travelling diagonally across your drawing, the marks will be horizontal. The tones of reflections usually have a different value from the object, either slightly lighter or darker depending on conditions.

Time taken: 2½ hours

Opposite

Welsh Waterfall

This waterfall is one of many in a beautiful valley in South Wales. I chose to draw it using coloured pencils because I wanted to capture the warm autumnal tones.

Time taken: 2½ hours

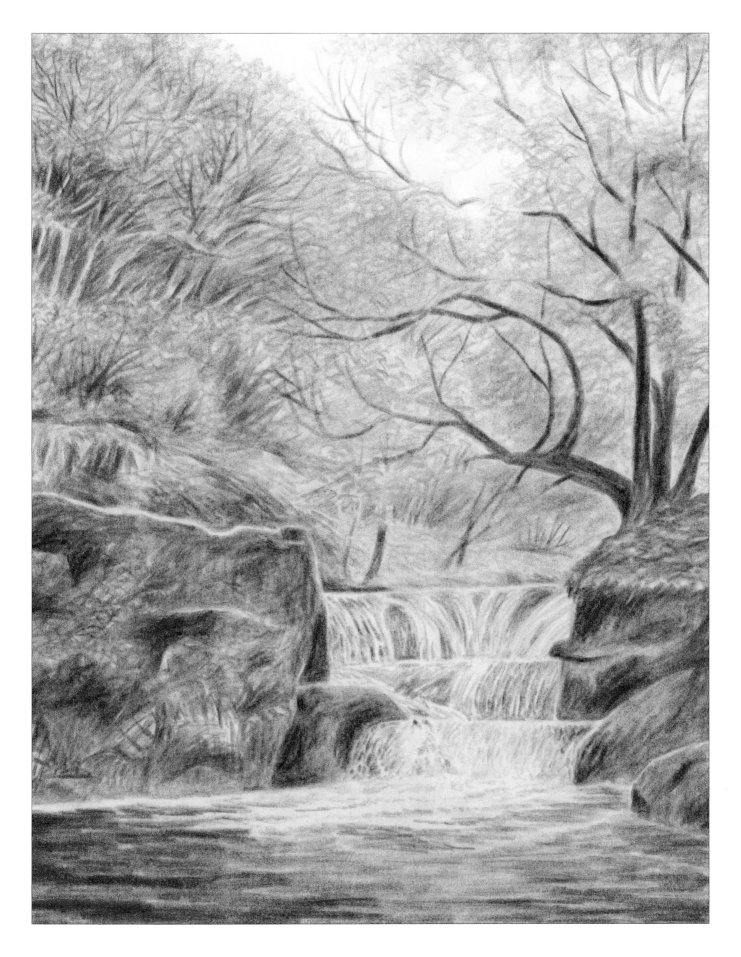

People and animals

People and animals in a picture will always draw the eye. If your picture is intended to be primarily a landscape, take care to make any figures you include very small and inconspicuous. The opposite applies if the people or animals are the reason for your picture; in this case, arrange everything else around them. Most important of all is that you should do one or the other – half-measures will not produce an effective composition.

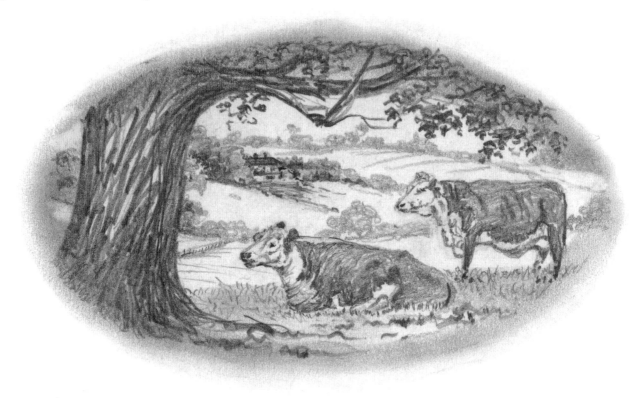

I drew these cattle in the middle of a flat field, but when I came to make a picture I included a large tree to give a sense of scale. The buildings were included to complete the story of these farm animals.

This is a group of horses which are all approximately the same height, standing in a flat field. The scale of the individual horses diminishes as they recede into the distance, but their eyes are all at the same level. Of course, this also works with other types of animals, and people!

Figures in a landscape

Putting a figure in a drawing as a focal point can work well, but I would suggest that you make it a back view to avoid giving the figure a personality – unless, of course, you are including someone you know.

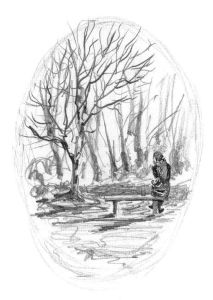

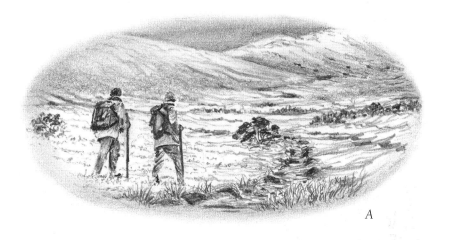

A

If you decide to have figures in a landscape, try not to put them in the centre of the picture. Here, the figure is on the end of the bench rather than in the middle, and is balanced effectively by the trunk of the tree on the left.

An important question when putting in figures is whether you want a drawing of people in a landscape or a landscape with people in it. If it is the latter, ensure that the figures are small enough to be 'discovered' rather than to arrest the eye. Figure A above is a drawing of people in a landscape, while Figure B below is the same view, but is primarily a landscape with people which are almost incidental.

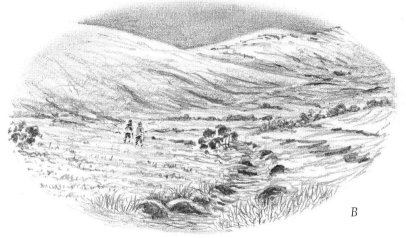

B

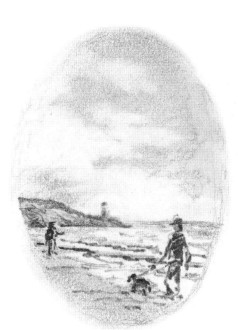

The figure with the dog leads you into the picture, while the figure further away arrests your eye and stops it from running off the picture, which makes the lighthouse the focal point.

65

DRAWING TREES

by Denis John-Naylor

Having decided to learn how to draw trees, or improve your existing skills, you will want to make fast progress. It is the aim of this section to help you succeed at this. You will be shown in easy stages how to draw trees to a high standard and to a high level of satisfaction. Trees are as individual as people and must therefore be approached as such by the artist.

Drawing trees for enjoyment, or making finished works, has its advantages because of the endless supply of models available. Trees, shrubs and a variety of foliage are in plentiful supply most of the time, almost regardless of where you live. You can observe them at close quarters or from afar, with or without their leaves, seeds and fruits. Photographs, magazines and books, as well as television programmes, are also useful sources of information.

It is no coincidence that the most proficient artists are those who draw often and persistently. It is this frequent practice that will most rapidly develop your ability. You will learn how to organise your tree drawing in terms of shape, form and texture, and how to introduce variety into your drawings through the skilful use of line and tone. Just as importantly, practice will aid the development of your all-round drawing skills and add to your progress as a developing artist.

In learning from this section, you may initially adopt my methods, but please always try to make time to experiment for yourself. This will help you to develop your own approach and allow your own unique style to emerge.

Success is within anyone's reach. Your rewards will soon come if you make a determined and consistent effort. Do not concern yourself with how long your drawings take, but with what you achieve and learn with each one. Art is not instant. Good luck!

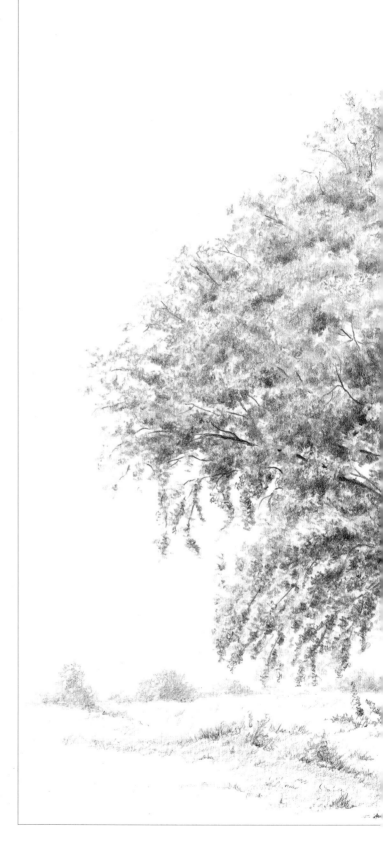

White Willow
370 x 285mm (14½ x 11¼in)
A magnificent tree in full leaf.

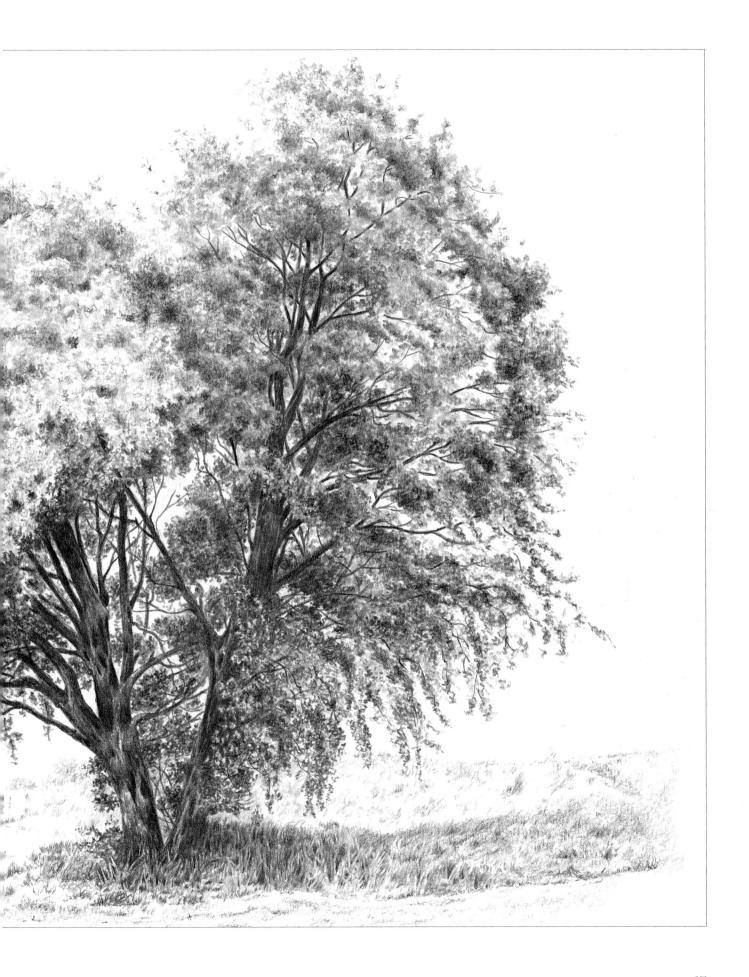

Tips and techniques

Sharpen your pencils to a long point using a sharp craft knife. Harder pencils generally give lighter tones, and softer grades give darker tones. Much depends on the amount of pressure you use.

Always have a piece of clean scrap paper under your drawing hand to keep your work clean. Make sure you lift rather than slide it to a new position, to avoid smudging.

After sharpening a pencil, strike it on a piece of scrap paper to smooth the working side or end, ensuring that you get the mark you want when you begin your drawing. Repeat this process every time you pick up a pencil to resume drawing.

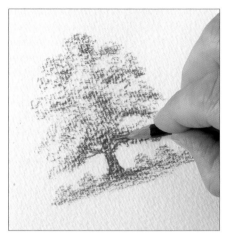

Using a gentle circular motion with the side of the pencil will pick up the paper grain to produce various textural effects. The example above was done on Not surface watercolour paper.

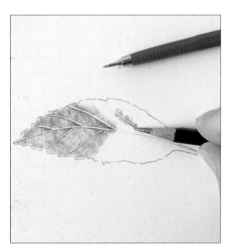

Impressing grooves into the paper with a fingernail or impressing tool allows you to tone over with a pencil, leaving delicate lines clear.

Lay down an area of tone, then use a rubbing stump (tortillon) to spread and smooth out the pencil marks.

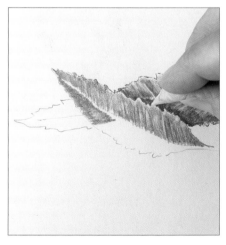

Mould your putty eraser to a point or flat edge and use it to draw fine lines into areas of tone. A dabbing motion will delicately lift tones. Do not let too much graphite build up on the eraser before remoulding to make a clean edge.

Quick sketches like these two can be achieved by using a textured watercolour paper and the side of a soft pencil. Start by observing the proportions of the tree and making some appropriate guide lines. Then lay a middle tone over the whole area of the tree, picking up the paper texture and leaving some spaces or sky holes in the foliage area. Through half-closed eyes look for the main dark areas in the tree and reinforce these by using heavier pressure but still using the side of your pencil. Now look for any really light areas and using your putty eraser, remove tone to suit. Keep doing this until you build up a broad pattern of lights and darks that suggest the tree form. Look for branches going through any gaps in the foliage and put these in as silhouettes with the point of your pencil. The trunk is usually in shade, if only partial, from the overhead foliage and will show dark. The top area of a tree usually appears dark due to the fact that you are looking at the underside of the leaf masses, but the light source is from above.

Drawing bare trees and branches

This pencil drawing was done using one of my ballpoint pen sketches as a reference (see page 74). The fact that the drawing is much larger than the sketch means that there is more space to fill, so you need more detail and textural information. Much practice and regular observation of bare trees and their details will help you to get to this point in your progress. You will develop a store of remembered features to help you create missing information in a drawing.

A range of subtle changes in tone will be required to form features such as these. Note that no lines are left visible.

I sometimes change the actual pattern of light against dark if this helps the viewer to understand more clearly what is happening. These overlapping branches might have looked more uniform in tone, but I have exaggerated the contrasts in order to show where one branch passes in front of another.

Split Bole Oak in Winter
330 x 260mm (13 x 10¼in)

76

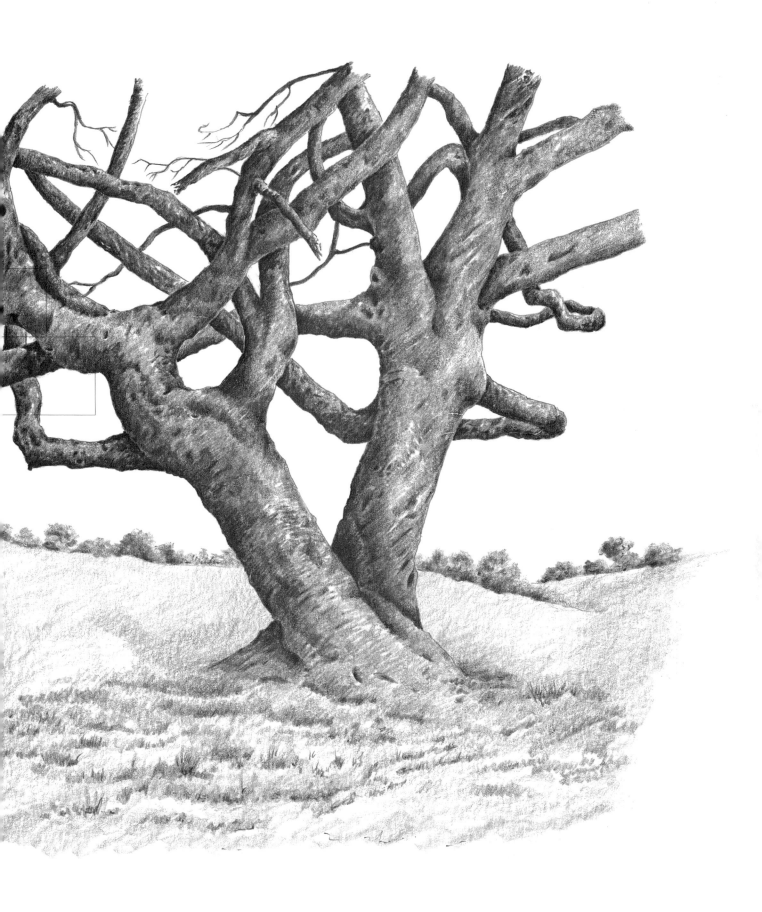

Bark textures

There may not be many situations where detailed bark rendering is called for but it can be quite eye-catching if used on a major tree in the foreground of a drawing. It will also prove to be a worthwhile learning and skill improving exercise.

London plane bark

The London plane tree has quite a smooth bark, light grey in colour. It sheds thin flakes to reveal light patches of yellowish-green underbark. Subtle rendering is required to show this bark well: mostly side of pencil work using a range of pencil grades.

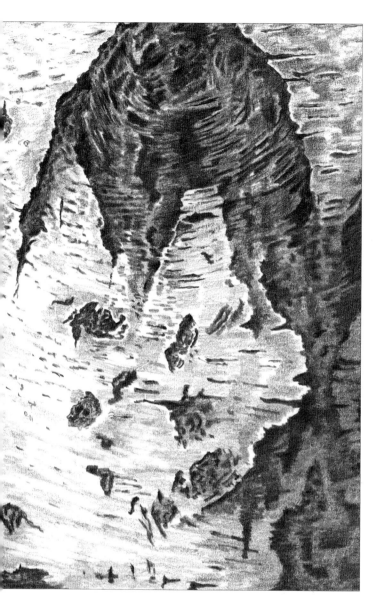

Silver birch bark

One of the most commonly recognised trees in winter or summer. The mature specimens have a warm white bark which contrasts with the deep black fissures that develop. This makes a good contrast in tones for a dramatic pencil drawing. Silver birches make excellent trees for the foreground, where you can show the bark texture to good effect. For this one you can really try out your different pencil pressures to create the contrast in tone. Note that the dark areas have a range of darks, and light areas have a range of lights. If you do not reflect this, your drawing will look flat.

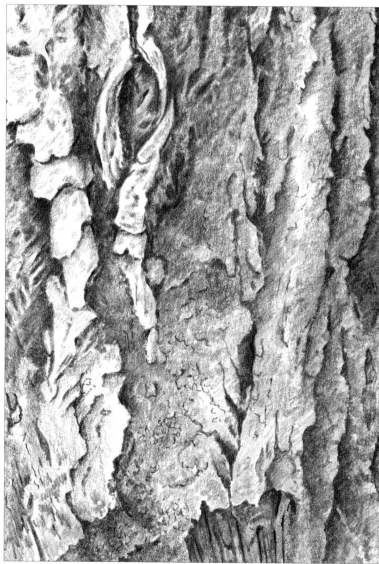

Weeping willow bark

This bark is grey-brown, sometimes showing deep, irregular-shaped fissures with fairly flat areas in between. It is very varied and a difficult bark to show well, but worth the practice. You will need to use lots of side and end of pencil work.

Light and shade: Lombardy Poplars

This tree's tall, elegant shape is useful in landscape drawings as it links into the sky space and balances out horizontals in the composition. Two trees together and overlapping give the opportunity to use contrasting tones of light against dark against light. Make a point of observing trees in a strong side light. This will help you to grasp this important principle.

I planned this drawing using the sketches shown below, considering the elements of composition, shape and tone that are all part of the process of designing a picture. To introduce variety and interest, I made the two trees different in height, with one of them in front of a hedge and the other growing up through it. I had some photographs of other Lombardy poplars for texture reference.

A drawing like this one will take some hours to complete, so the main body of the work is always done back in the studio. I do not usually draw any one tree or group of trees on site for more than a couple of hours at a time as the changing light alters the light and dark patterns of trees too much. This is where sketching becomes most helpful, since you can get quite a lot of information down on paper in a relatively short time.

You will need
2B, 4B, 6B and 8B pencils
Putty eraser
Heavyweight cartridge paper
Scrap paper

In planning your composition, it helps to balance the verticals and horizontals. Tall trees like poplars are useful for this reason in a landscape drawing.

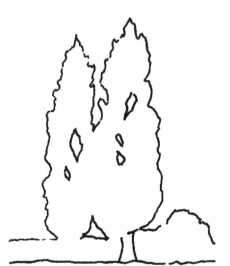

Two trees together create an interesting variety of shapes.

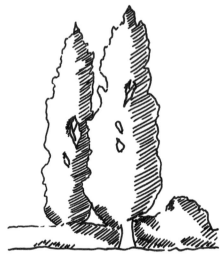

Look for the play of light. Overlapping trees create contrasts of light against dark and dark against light.

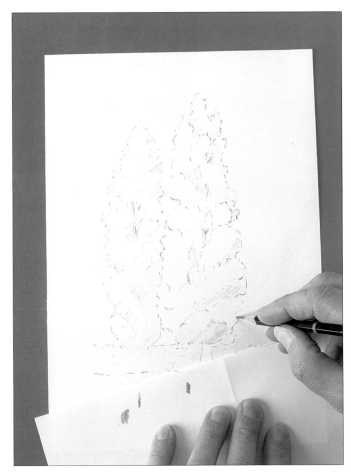

1. With a sharp 2B pencil, make a series of squiggles and dots to indicate the general shape and placement of the whole composition. Include some space for a little foreground work. Once you are happy with the shape and size of the drawing, add some general toning to suggest form and the direction of the light. Mark in where the branches are going to be.

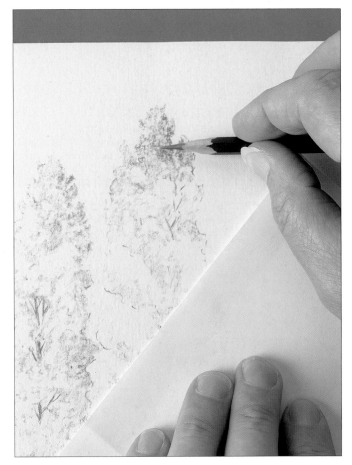

2. Lay in more tone to indicate further form, with the side of the 2B pencil. The texture of the paper grain can remain, as it almost looks like foliage. Work over the areas that will eventually be darker to gain a feel for furthering the form, before making final marks. Refine the branches.

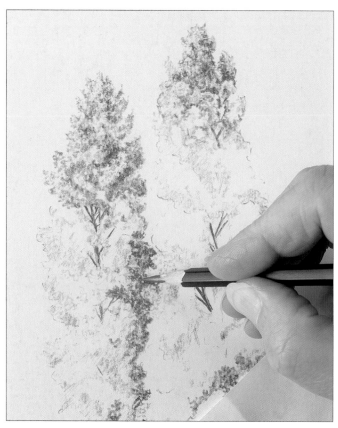

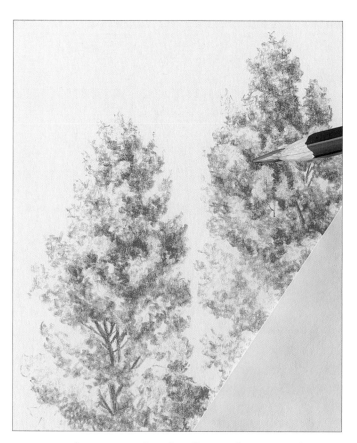

3. Make a good flat on the side-end of the 2B pencil and lay in some heavier tones to divide the area between the two trees. Apply similar toning to the dark areas under the trees and around the bole of the tree in front.

4. Using the 4B pencil with a flat on the tip, work some darker tones to further divide the large leaf masses. Notice that the tones are mainly laid down as marks, not as solid filled in areas.

5. Use the 4B pencil to darken the hedge under the main tree around the bole, render the fluting on the bole and indicate a cast shadow at an angle across it. Further render the left-hand tree and hedgerow with the same pencil. With the side of the 2B pencil, make some marks on the foreground area to indicate undulations in the field.

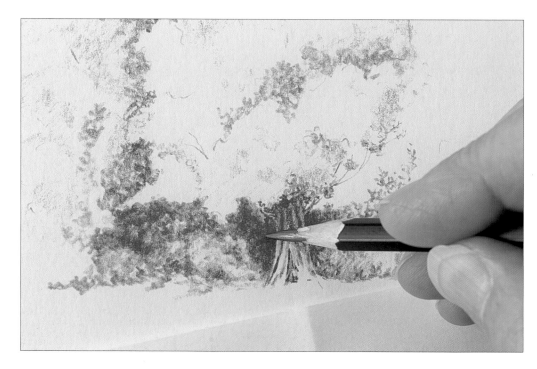

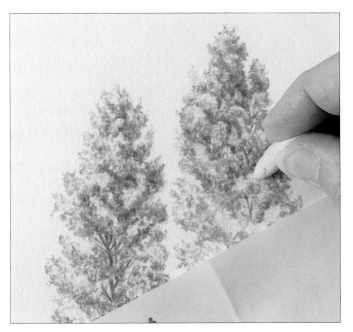

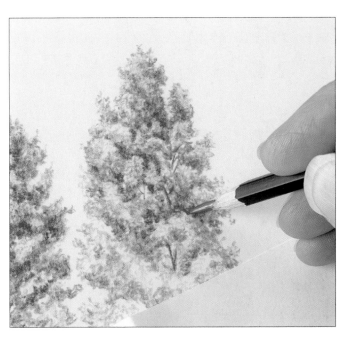

6. Lift areas of tone using a putty eraser if required to vary the shape and size of the leaf masses. Note the larger leaf masses on the most prominent tree.

7. Using some scrap paper, work a small flat on the end of your 6B pencil. Use this to make some darker tones within the previously made tonal areas. As you use this soft pencil, the flat will get larger. Do not let it get too large before re-forming it.

8. Establish the darkest area around the right-hand tree bole to help accentuate the features of fluting and cast shadow. This is the light against dark against light principle, which creates interest and drama.

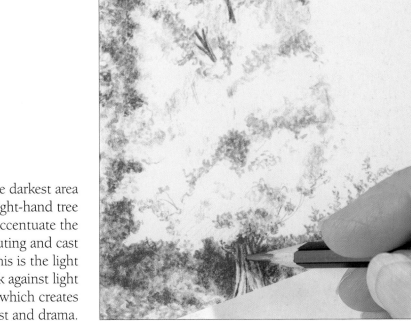

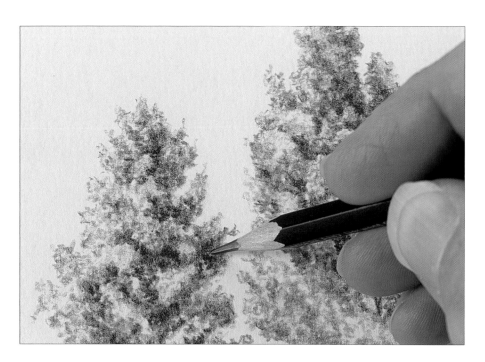

9. Using the 4B, 6B and 8B pencils, further establish the lights and darks of the main tree's large leaf masses. Lift areas with the putty eraser where required. Continue working in this way to near completion.

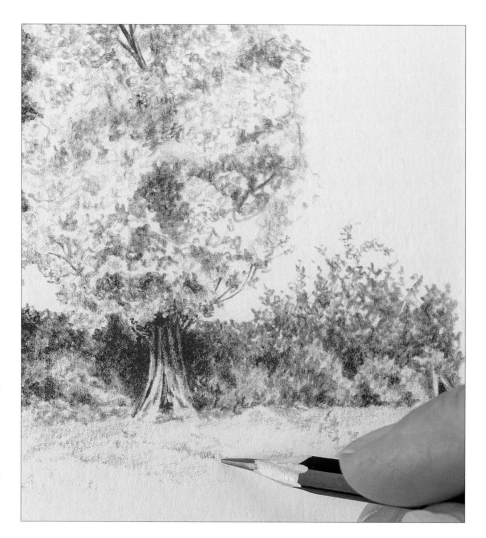

10. Work some detail into the rest of the hedge. Add some stray branches at the right-hand side of the hedge. Introduce some more foreground marks. Put the drawing aside for a while before looking it over for any further corrections that may need attention. Work to completion.

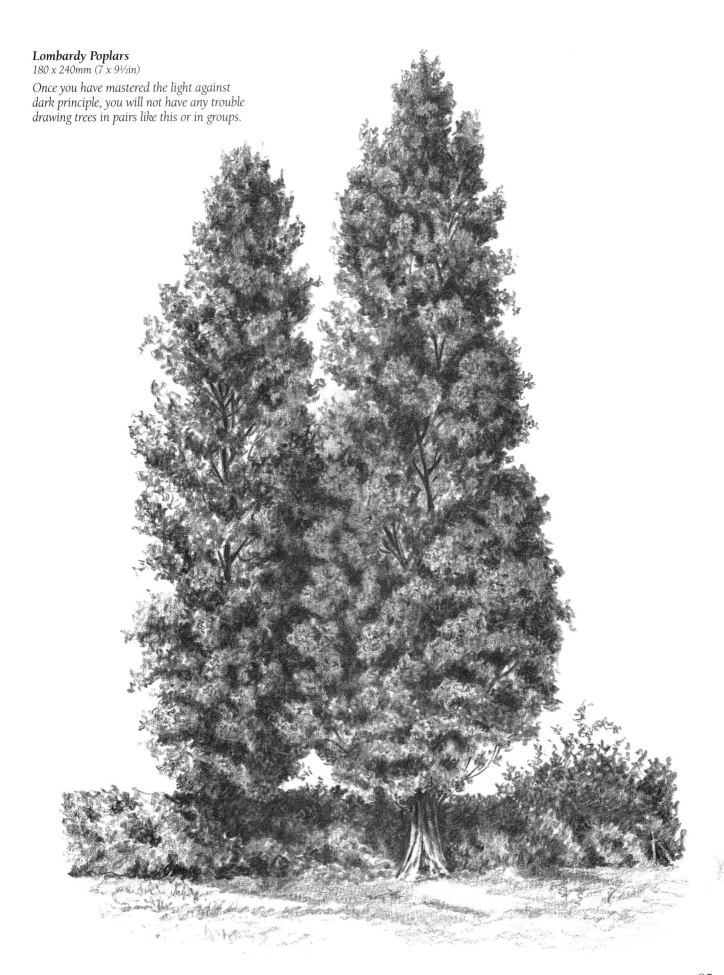

Lombardy Poplars
180 x 240mm (7 x 9½in)

Once you have mastered the light against dark principle, you will not have any trouble drawing trees in pairs like this or in groups.

85

Trees in the landscape: Bankside Birches

Landscape drawing will sometimes involve capturing tree reflections. In gently moving water, reflections can break into all kinds of abstract, fragmented shapes. The distance that a reflection extends below the waterline can be taken as equal to the height of that object above the waterline. The size of object and reflection can be taken as equal. However, the reflection may be carried further by water movement.

You will need
Pencils: 2B and 4B
Putty eraser
Heavyweight cartridge paper
Tracing paper
Paper rubbing stump
Scrap paper

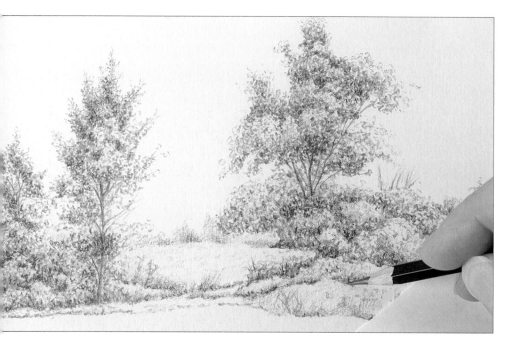

1. Using the 2B pencil, lightly mark out the proportions and placement of the landscape features. Progress the landscape area to a fairly complete state by carefully placing a variety of tonal marks using a 4B pencil. Reinforce and lift tones as required. Only after you are fairly satisfied with this step should you consider working the water and reflections.

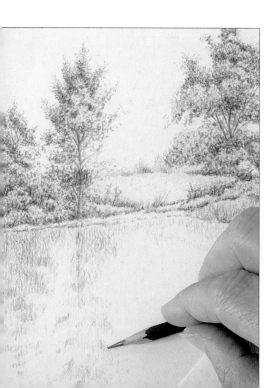

2. Use your pencil as a gauge to mark the lengths of the reflections below the waterline. Using short, vertical strokes with the side of your 2B pencil, start laying in some broad areas of light tone for the reflections.

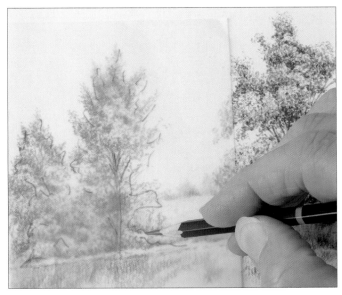

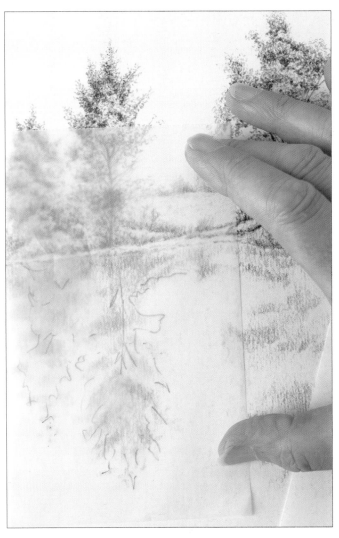

3. Continue with short strokes of the 2B pencil, noting carefully that where the actual tree branches grow upwards, their reflections will go downwards. If this is initially a problem, use some tracing paper to trace a rough outline of the trees.

4. Turn the tracing upside down and use it as a guide only to check your drawing of the reflection.

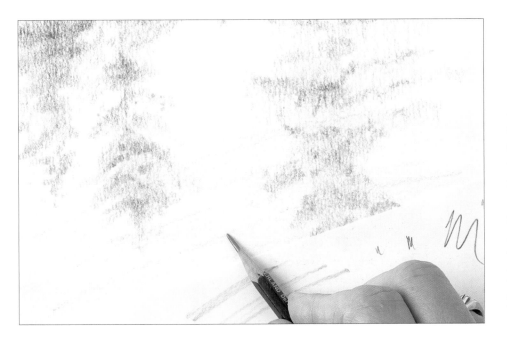

5. Now put in some of the darker tones with the 4B pencil and continue getting a general upside down likeness of the image above the waterline. With the side of the 2B pencil, sweep in some strokes of tone to give an indication of where the water ripples will be. Using the side of your finger, carefully smudge the graphite over the whole of the water area.

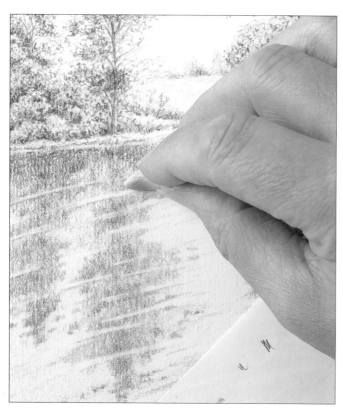

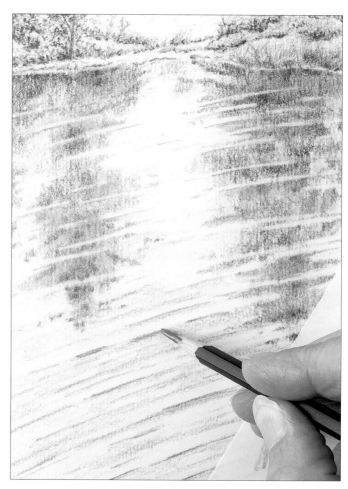

6. Continue with the 2B and 4B pencils, adding tone to give a stronger reflection. Then, using a putty eraser pinched to a thin edge, remove some areas of tone at the far edge of the water. Work in the same direction as the ripple marks. Increase the width of the removed areas as you come forward in the picture. Note that parts of the reflections are carried away along the line of the ripples.

7. Using your 4B pencil with a small flat on its end, apply some further tone to the front edge of the areas that you previously cleared with the putty eraser. This will add depth to the ripples.

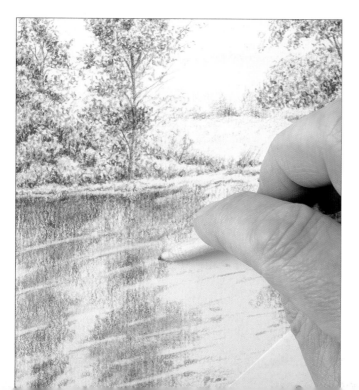

8. With the rubbing stump, gently smudge some pencil marks to hide the grain of the paper, adding another texture to the water surface. Continue adding and removing areas of tone, making these features more prominent by means of size and contrast the nearer you move towards the foreground.

Opposite
Bankside Birches
210 x 297mm (8¼ x 11¾in)

The drawing merely creates an impression of the scene. For rougher water the reflections would be even more fragmented, whereas for smoother water the reflection would show more detail, almost like a mirror image.

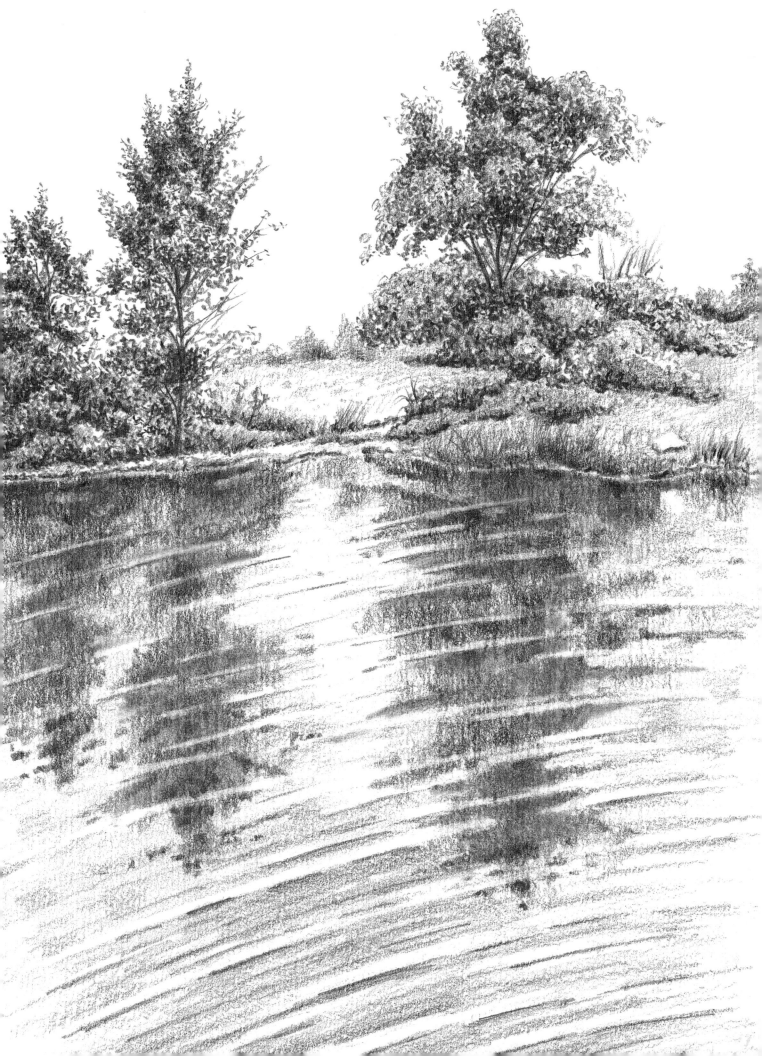

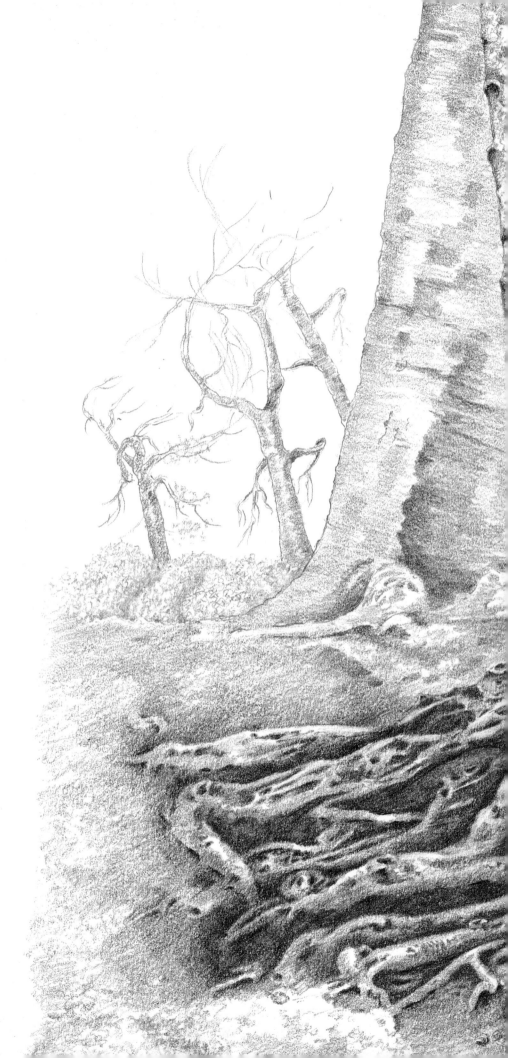

Tree Roots
350 x 285mm (13¾ x 11¼in)

This landscape drawing is on a different scale, and contains more detail of an individual tree. Only where the water has washed away the soil will roots be exposed as they were here, by the bank of a dried up or diverted river.

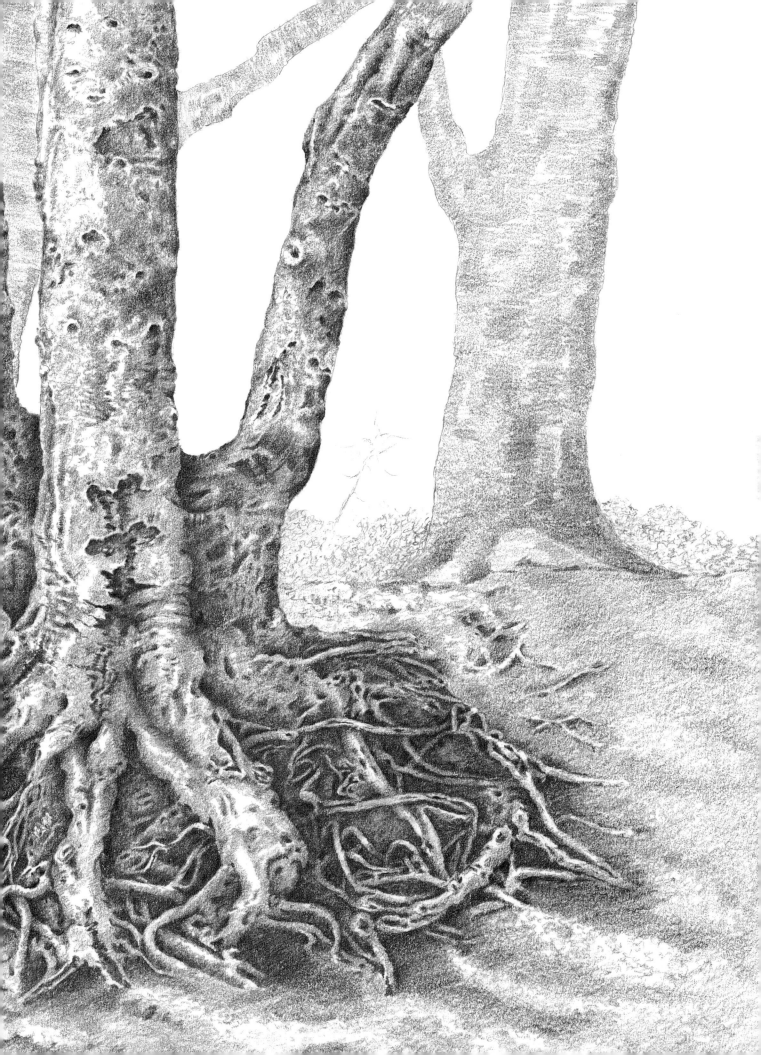

DRAWING PETS

by Sally Michel

Drawing involves exploring the form of individual objects, and how different forms relate to each other in three dimensions. As you draw you are gathering information, and when you have enough information you can use it to make a picture. Each time you draw the same thing you add to your knowledge of it.

So, how do you start? Look first, without drawing, then when you have sorted out in your mind what you are seeing, put it down on paper. That's all there is to it, really. When you've been drawing for a while you will find that you are seeing more and more, and that it gets easier to analyse what you see, and easier to put it down on paper.

A study of the head of a sleeping dog done in water soluble pencil – a little water was used to loosen the tone.

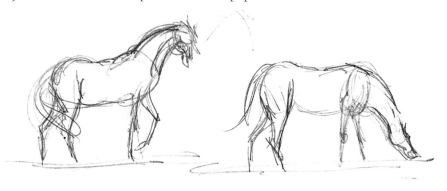

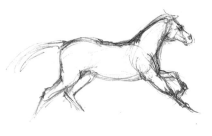

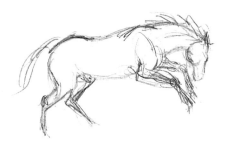

The main drawing was done using a soft black pencil. The colour was provided by watercolour pencils – reddish-brown and chrome yellow on the cat and olive green and cobalt blue on the background. Water was added once the drawing was completed.

The drawings of the horses were done from life in B pencil.

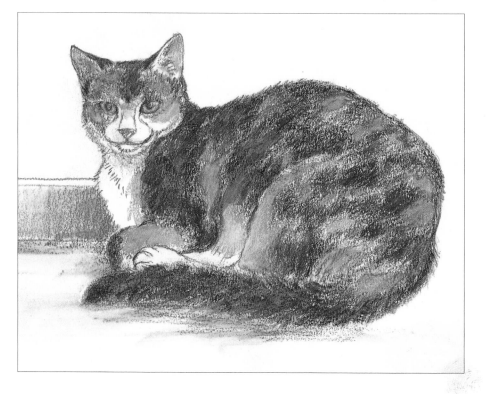

92

You can use almost anything to draw with – pencil, charcoal, crayon, chalk, pen and ink; brush drawings with ink or paint. Each has its own characteristic range of marks, depending on the paper you use to draw on – smooth card, textured pastel paper, rough rag paper, all add their own individual quality. If you use colour, remember that form, not colour, is the primary subject.

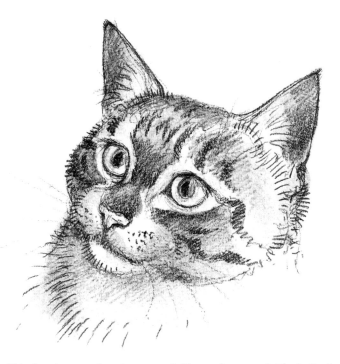

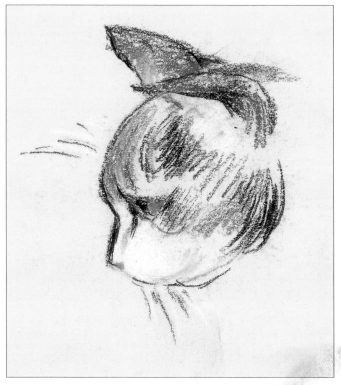

This drawing was done in water soluble graphite pencil. The bulk of the drawing was a straightforward pencil drawing, with water only added for extra tone afterwards.

The main drawing was done in black using a hard pastel crayon. Colour was added in reddish-brown, white, and a touch of pink and yellow pastel pencil.

A study of my cat, Lucy. I did a straightforward drawing in watercolour pencil, defining the markings of the cat, and added colour afterwards with watercolour crayons. I added a little water at the end to blur the markings.

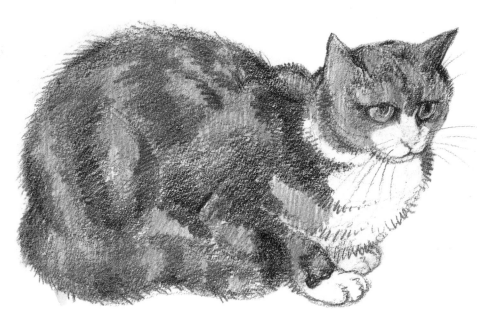

How to start

When drawing pets, it's simplest to start with a sleeping animal for the obvious reason – you have time to do your looking for longer. Don't be too ambitious in the early stages of your drawing – go for the main forms first and leave the details for later. Think of your pencil lines as marks enclosing a solid form rather than a map of the edges. If your subject moves, start another drawing. Even tiny rough sketches convey some information and are worth keeping.

These drawings of my Jack Russell terrier are done with an HB or B pencil – my favourite basic medium for making studies from life – responsive enough for recording swift movement, but hard enough to define small detailed forms clearly.

There's no need for a lot of shading. It is often over-used by the beginner; a highly shaded drawing with exaggerated contrast of light and shadow doesn't necessarily show superior skill. I prefer to add shading to a drawing, if at all, to indicate differences of tone and patterns of marking.

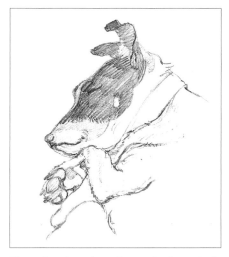

These drawings show the result of a typical session of drawing a sleeping pet – some sketches of more or less the whole animal, depending on how long it stays in a particular place or position, with a number of drawings of details of ears, feet, etc. and positions held for a few moments with no time to finish.

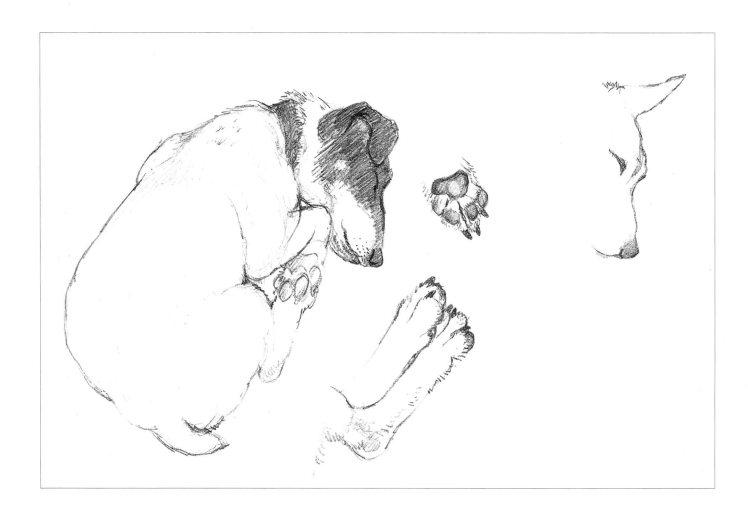

94

Perspective

Don't be afraid of terms like 'perspective'. All perspective means is how things look to you from where you are looking at them. Move your head and the perspective changes.

There are many rules that can be used to construct a picture from different pieces of information when the object portrayed is not in front of you. Knowing these rules can prompt you to look at the world in ways you might otherwise have missed. More specifically, they can help you understand the principles of exactly how distance affects the apparent sizes of what you see, the behaviour of reflections and the different factors affecting shadows thrown by the sun or artificial light sources.

When you draw from life the information is all there. Keep to the same viewpoint and, if you draw what you see, the perspective will be correct. The difficulty lies in drawing *only* what you see. Resist the temptation to put in details that you think you know are there but can't quite see. Take a closer look and check it later, but for now draw only what you *can* see.

A vertical board held at right angles to your line of vision helps you to draw the proportions correctly. If your drawing surface is too nearly horizontal, its own perspective will interfere.

Remember that the difference between the actual and the apparent size of an object is much bigger than you might imagine it to be.

The cat's head appears larger in the picture below than in the one above because it is closer to the artist.

Composition

Drawings from life of your cat or dog are complete in themselves; full of life and character, they prompt recall of far more than the sketch actually contains, even when the animal is not present.

If you wish to do a more elaborate picture of your pet, your life studies are the essential starting point. You can add a decorative setting by choosing a pleasing background that might not have been available at the time. For example, perhaps you would like to present your cat in an elegant and aesthetically pleasing setting and you have a particularly successful life-like drawing of him, but at the time he was sitting on the breakfast table, on a newspaper with a background of milk bottles and used cereal bowls. He might have been nicely posed in front of a bowl of flowers but beside some large, awkwardly shaped article that would take up far too much room in the foreground.

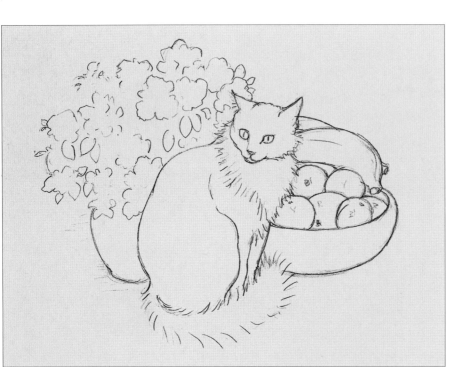

Decide what elements you want to include in your picture and compose it. Try the different elements in various positions – make a rough sketch of each one on a scrap of paper and move them about in relation to one another to find the most pleasing combination – no need for much more than an outline at this stage. Try to get a good balance between the separate elements of your composition.

Justin the Cat

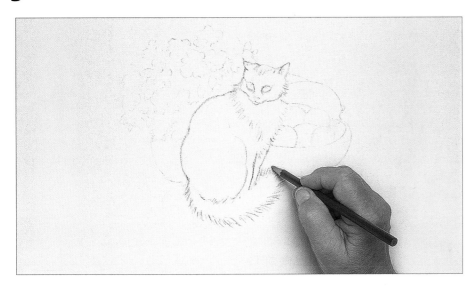

You will need

Rough watercolour paper

Coloured pencils – medium grey, olive green, orange, yellow ochre, dark red, purple, grass green, yellow-green, bright yellow, light grey, dark grey, medium brown, soft black, medium blue, lilac

Sharpener

1. Use the medium grey and a light touch to draw the basic shapes of the cat.

2. Use the olive green to draw the basic outlines of the pot plant.

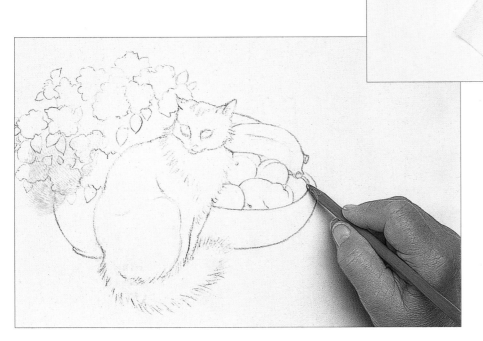

3. Use orange, yellow ochre, dark red and purple pencils to draw the bowl and fruit.

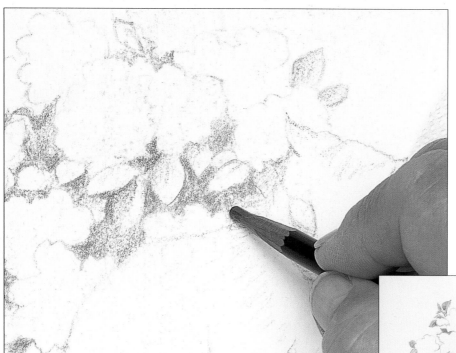

4. Start to work up the leaves with the grass green, then, applying colour on colour, use other greens to develop the dark areas of shadow between the flowers.

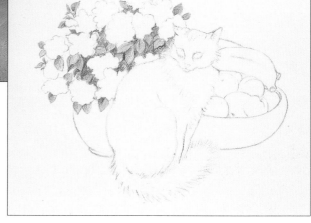

5. Work up the bright highlights on the leaves with the yellow-green, then intensify the deep shadows with purple.

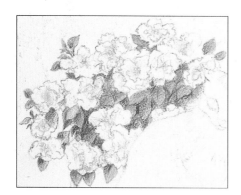

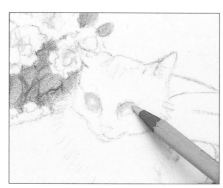

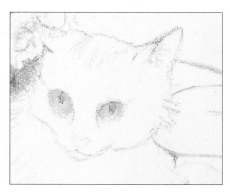

6. Now work up the shape of the white flowers with touches of yellow-green and olive green; develop shadow areas on the petals and knock back some of the brighter greens on the leaves.

7. Colour in the cat's eyes with bright yellow, adjusting the applied pressure to create a roundness to the eyeball.

8. Emphasise the curve of the eye with the light grey pencil, then use the dark grey to develop the pupil.

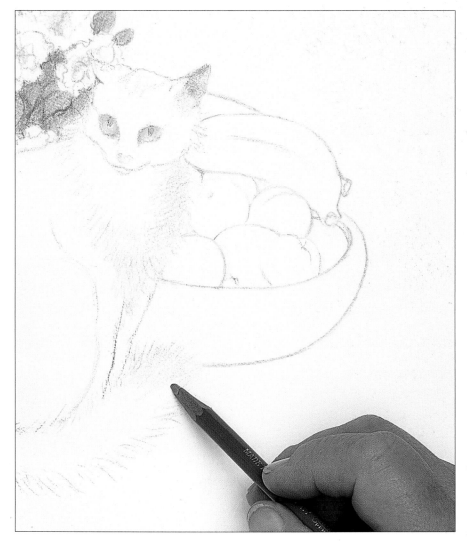

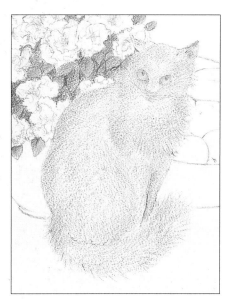

10. Develop the cat's fur with the light grey pencil. Work from the head downwards, adjusting the applied pressure and depth of colour to create form.

9. Shade the insides of the ears with medium brown, varying the applied pressure to create form. Use the same colour to define the underside of the eyes and the nose and mouth. Black cats often have a brown tinge to their fur, so, using the same colour, apply a light shading to parts of the chest and tail.

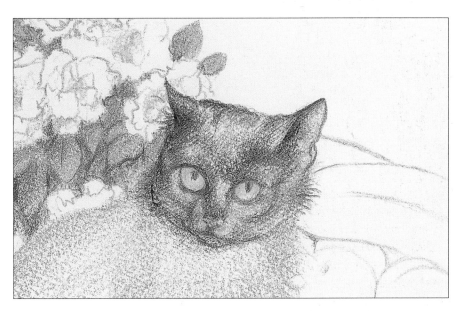

11. Use soft black to work up the darkest tones on the cat's head, adding detail around the eyes and ears, then add touches of purple.

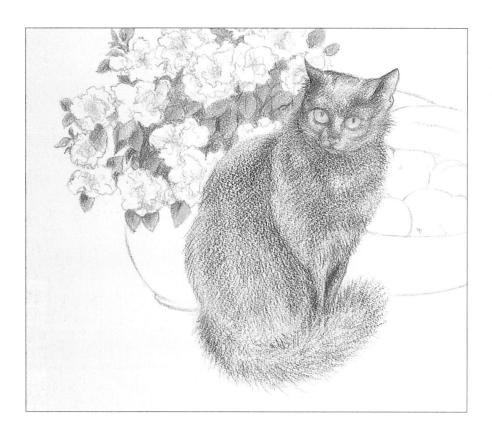

12. When you are happy with the tonal structure of the head, work up the darks on the body with the soft black.

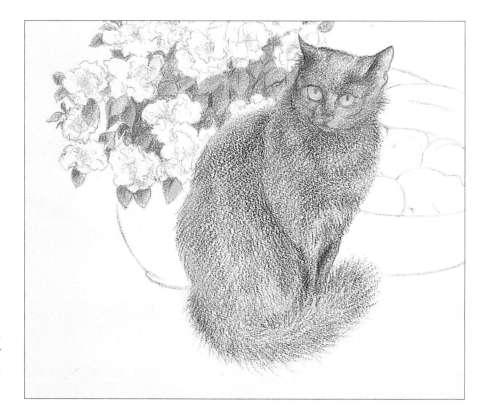

13. Accentuate the lighter parts of the body fur and the head with the medium blue.

14. Enrich the dark parts of the body and head with purple.

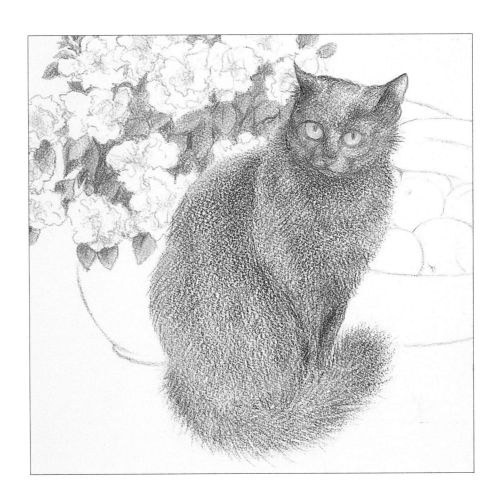

15. Use the bright yellow to block in the bananas, the yellow plums and a base colour on the apples. Use the yellow ochre pencil to block in a base coat for the wooden bowl.

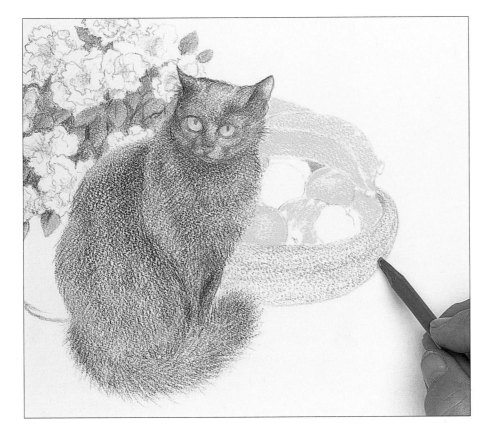

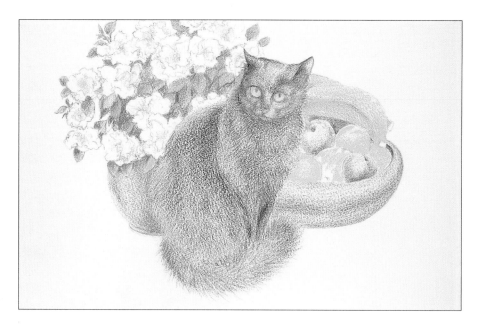

16. Use lilac to create the bloom on the purple plums and to block in the shape of the flower pot. These marks help link all the component parts of this composition. Develop the shapes of the bananas with touches of yellow-green. Use the purple pencil to add darks to the purple plums and to develop shadows on the bananas, the bowl and the plant pot.

17. Use the orange, shaded lightly with dark red, to work up the shape of the yellow plums. Work up and apply orange base colour for the apples, then overlay this with a variety of dark red tones. Use the purple to redefine deep shadows and the yellow ochre to warm up the wooden bowl.

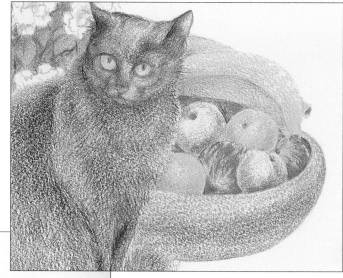

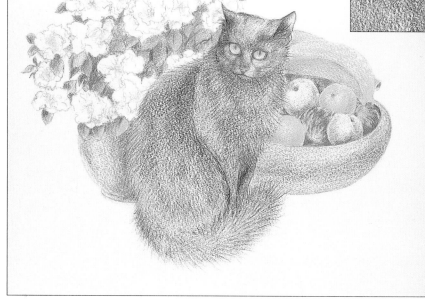

18. Sharpen the soft black pencil to a fine point, then add details to the cat: sharpen the shapes of its eyes; add in some hairs in the ears; flick in the whiskers; and add some hairs on its back, down the chest and round the tail. Add fine shadow lines around the fruit and bowl.

The finished drawing. Olive green has been added to the foreground to complete the drawing.

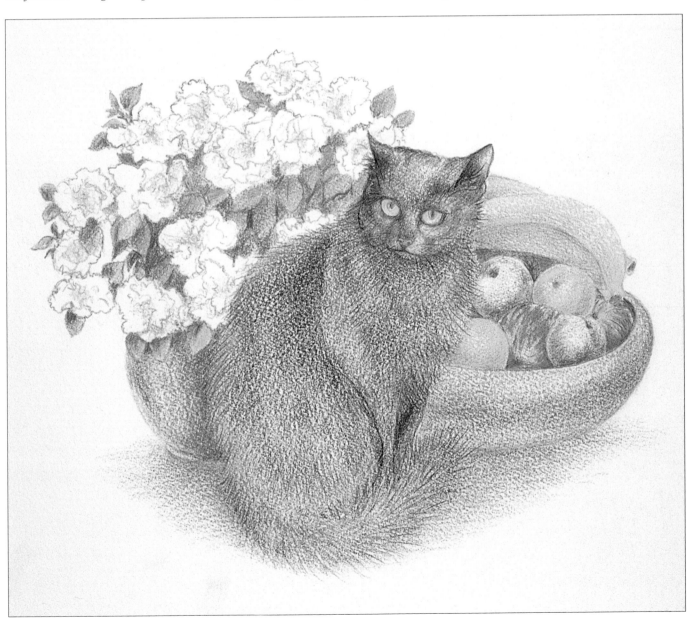

Anatomy

Try to get some idea of the anatomical structure of the animal you are drawing. First there is the skeleton, the bony frame composed of inflexible pieces that move against each other, but do not themselves change shape. They are moved by the muscles, which bunch up or stretch out so that they change the external shape of the animal.

Eyelids cover most of the eye, and movement of the eyes seems to change their shape; the ears can turn and move with movements of the skin.

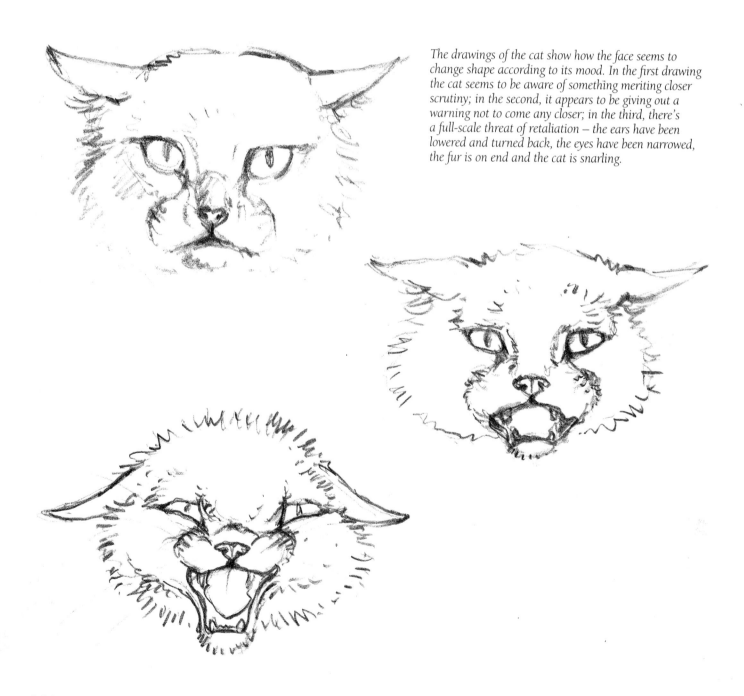

The drawings of the cat show how the face seems to change shape according to its mood. In the first drawing the cat seems to be aware of something meriting closer scrutiny; in the second, it appears to be giving out a warning not to come any closer; in the third, there's a full-scale threat of retaliation – the ears have been lowered and turned back, the eyes have been narrowed, the fur is on end and the cat is snarling.

In the picture below, see how the dog's skull, the hard inflexible box that protects the delicate brain, has a hinged lower jaw that allows the mouth to open very wide. The eye sockets and ear holes show that these organs are fixed in place.

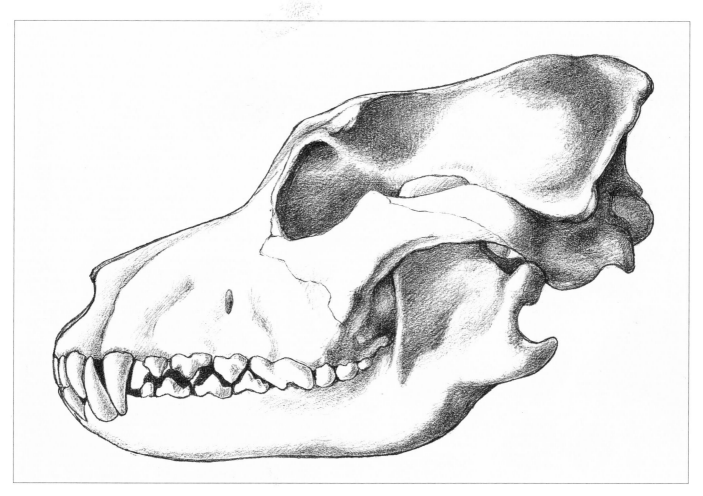

This drawing of the dog's skull is very different from the loosely drawn sketches from life of an active animal. I was able to take advantage of its immobility to explore at leisure not just its overall shape but also the small forms within the main shape that prevent it from being completely smooth and featureless. I have used a small amount of shading to emphasise this minor unevenness. It also demonstrates another approach to drawing.

The relationship between all animals is shown by the drawings on these pages. They show how the skeletons of human, dog and horse fit in their skins – they are similar in structure, though the individual bones are different in size, shape and number; for example, the horse has lost some toes and there is no external tail in the human.

All the main bones are recognisable in each animal. Each of them has a skull, a spinal column, a rib cage, a pelvic girdle, shoulder blades, a long bone in each upper limb and two smaller bones in each lower limb. The feet, though greatly evolved, all have vestiges of the same bone structure.

The muscles are joined at each end to a bone (directly or indirectly). They move the limbs by 'bunching up' so that the muscle becomes thicker and shorter. These changes naturally affect the shape of the animal; any cat owner will be familiar with the way their pet can change from being compact and rounded into an animal of a completely different form – long and stretched.

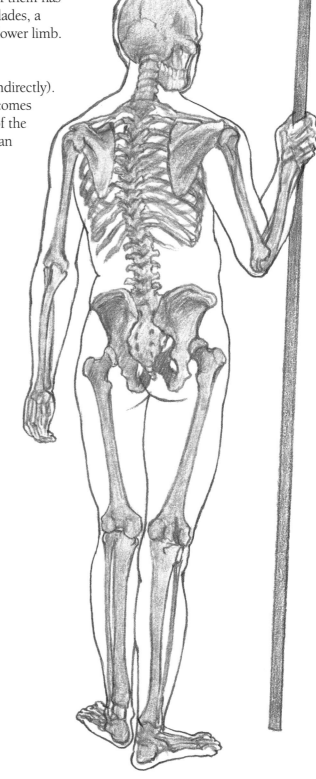

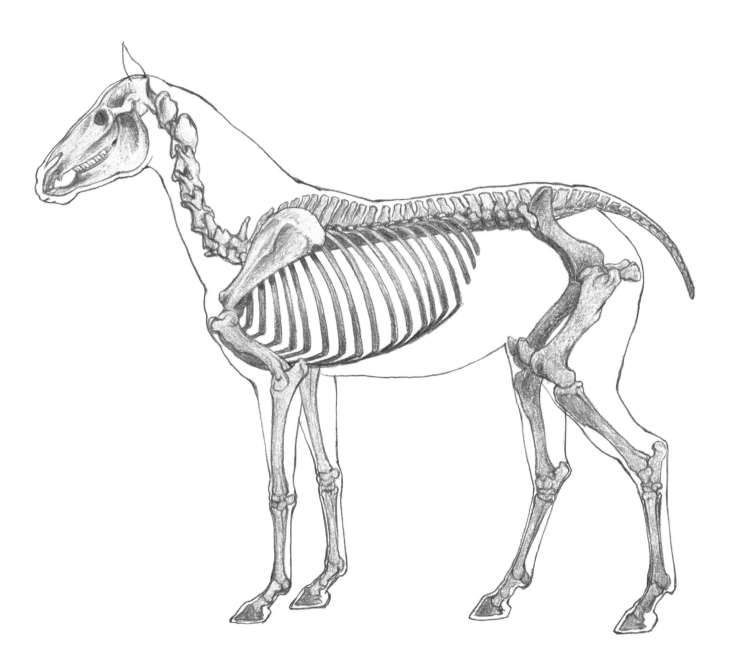

Each animal's way of life has led to changes in the skeleton and other parts of its anatomy through the millennia, and this can be seen clearly in the changes to the feet. The dog walks on the equivalent of its fingers and palm, and the horse on the one remaining toe on each foot, or more correctly on the nail which has evolved into a hoof. The dog's nails have become claws. In both species the hind foot is greatly elongated and the heel is halfway up the leg. These changes reflect both animals' abilities to run for great distances without tiring.

Drawing animals in their natural settings

Good pictures can be made of other people's pets in a wider setting; cats on garden walls, dogs out walking with owners, ponies or donkeys in paddocks, etc. Try sitting on a park bench sketching the view and including the passers by, both human and animal. A few examples of this kind of drawing are shown on these two pages.

It doesn't matter if your drawing is loose in handling and reticent about details. It all adds to the movement and liveliness of the result.

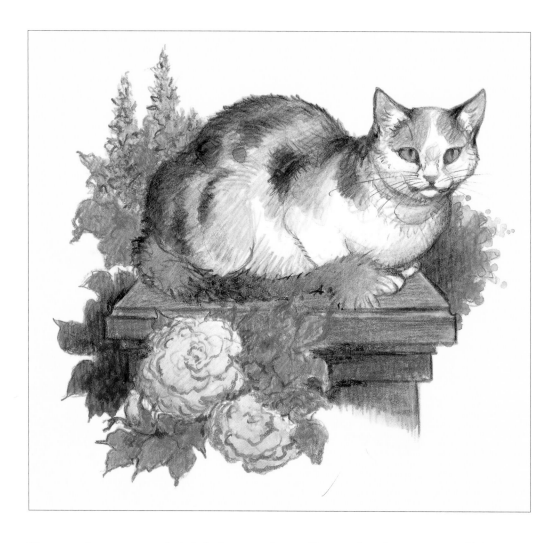

The cat on the gatepost posed nicely for long enough to enable me to draw her. Later on I added rather more in the way of floral background than was actually there to improve the composition and increase the decorative impact of the whole scene.

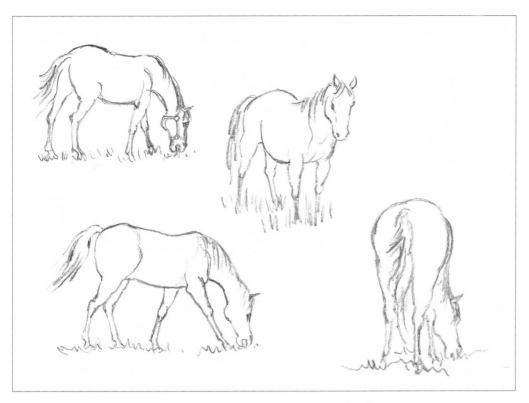

Horses and donkeys hoping for a titbit are often very quick to approach a human. When none is forthcoming they will obligingly move off and carry on grazing. This is useful as it gives you the chance to study details of the formation of their eyes, nostrils, ears and so on.

Dogs, of course, are more likely to be on the move unless two owners stop for a chat – a chance to get another interesting composition.

The Horse

I selected the horses for this study from all my life drawings of the horses – close-ups of their heads, sketches of them grazing and walking, details of the ears, eyes, etc. To make a better picture, some drawings of their field and various features – clumps of trees, gate, fence and so on – were used to make a more pleasing setting than the actual one.

You will need
Watercolour paper
No. 4 round brush
Water soluble pencils – greens, dark browns, yellow, raw sienna, lilac, purple, dark blue, warm brown, mid brown, black, light brown
Sharpener

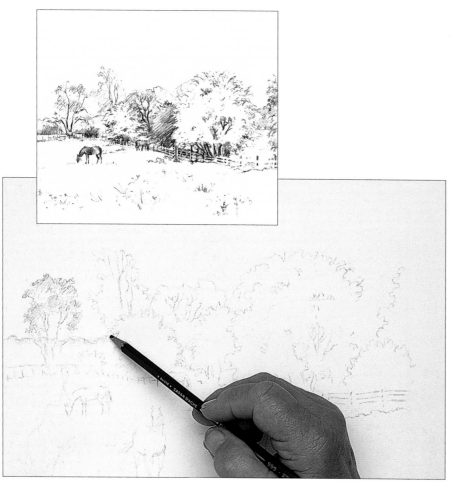

1. Compose the drawing on the watercolour paper. Use green to rough in the foliage of the tree at the left-hand side of the composition and to mark in the tops of the more distant trees.

2. Use a No. 4 round brush and clean water to soften the edges of the foliage. Clean the brush, then pull down the colour of the drawn line of the more distant trees.

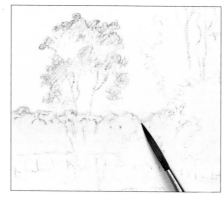

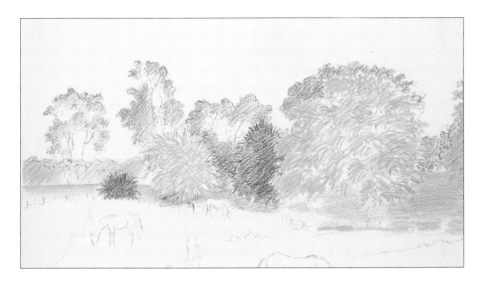

3. Gradually work across the composition, using the green and the dark brown pencils to lay in the base colours for the various elements of the background. Vary the tones to create form, and try to set light tones against darker ones.

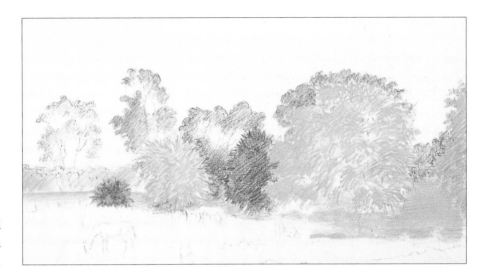

4. Use the No.4 round brush and clean water to soften the colours in the trees and fields. Leave to dry.

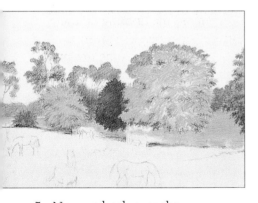

5. Now go back over the background, overlaying it with yellow, raw sienna and all the greens to create more depth. Introduce touches of lilac and purple to create shadowed areas.

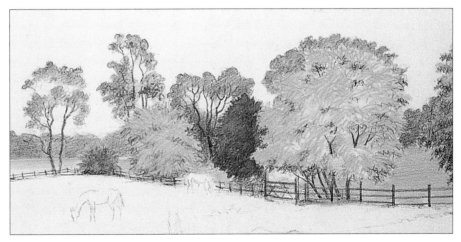

6. Use dark brown to indicate exposed tree trunks and branches. Use the same colour to draw in the fence, leaving a gap where the most distant horse will be. Use purple to darken the shadowed side of the trunks and dark blue to create shadows on the fence.

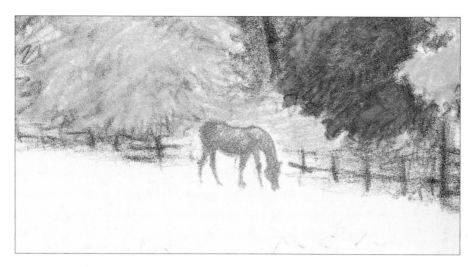

7. Use warm brown to block in the most distant horse grazing against the fence. I purposely chose this bright colour to counter the dark tones of the background. Even though this horse is quite small you still need to capture a natural pose.

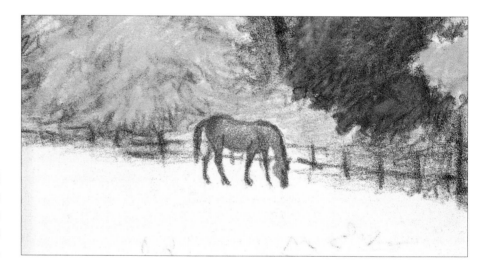

8. Sharpen the dark brown pencil to a fine point, complete the fence behind the horse then develop the detail of the horse, adding a tail, its feet, a mane and small shadows.

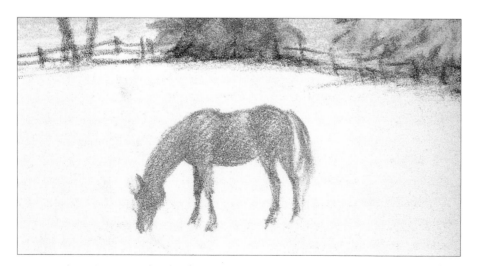

9. Use warm brown to block in the horse on the left-hand side. It is nearer to you than the first horse, so it needs slightly more detail. Use the mid brown to darken the front leg.

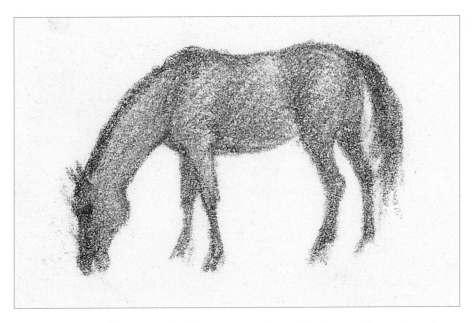

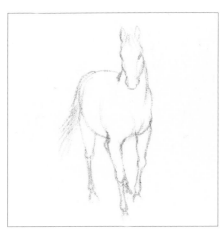

11. Use mid brown to draw the outline of the horse walking into the foreground.

10. Use the medium and dark brown pencils to shade over the undercolour to develop form and to detail the eyes and ears.

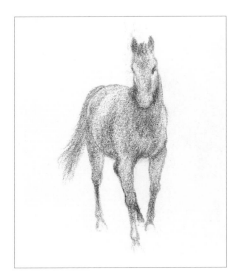

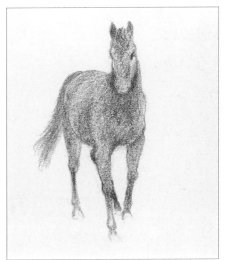

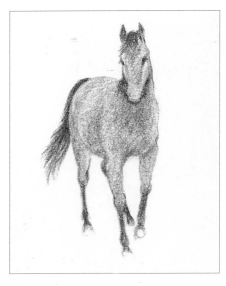

12. Use the same colour to block in the basic body parts, varying the tone to create form, and leaving the white of the paper as highlights.

13. Use light brown to develop the colour on the horse's chest, back, rump and head.

14. Complete the detail on this horse using dark brown and black.

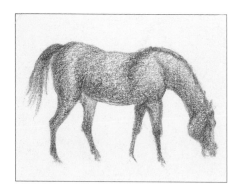

15. Use dark brown to work up the shape of the horse on the right-hand side.

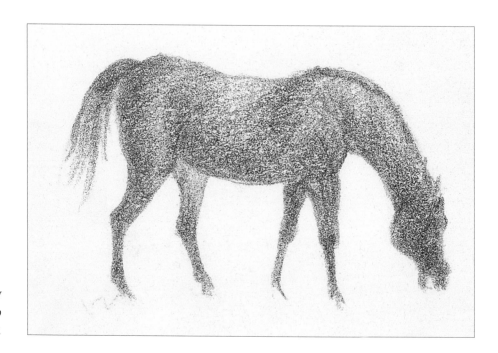

16. Develop this horse by blending the mid brown into the darker undercolour.

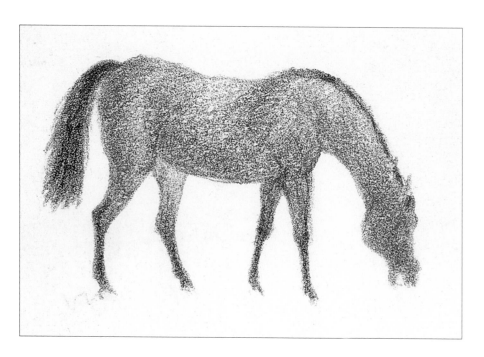

17. Finally, use the black pencil to add the fine detail.

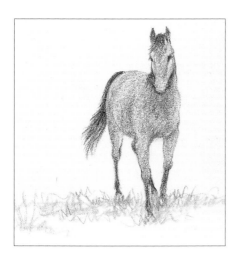

18. Use the greens to indicate patches of grass to ground each horse, and to indicate shadows from the background foliage.

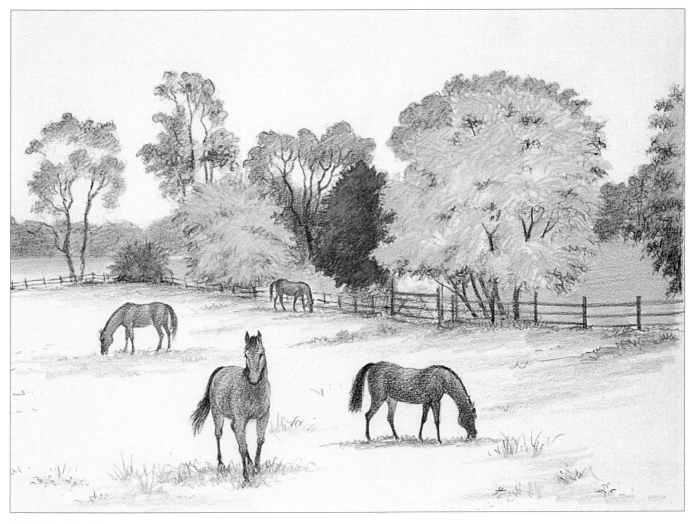

The finished drawing.

Dog portrait

This beautiful huge puppy is one of an uncommon breed – a Leonberger – popularly supposed to have been bred to resemble lions, but with more approachable personalities. Certainly, this young female (about 9 months old when I drew her) has a most agreeable temperament, a handsome mane and a blackish tip to her tail. I spent a couple of hours doing half a dozen sheets of drawings from life, observing her as she moved and walked around her garden. I also took a number of photographs.

For the portrait, I decided to use one of these photographs to base the picture on – not to copy it, but to use it as a reminder of what I had studied and drawn.

The first essential was to redraw all that part of the dog that was furthest from the camera. To have copied the photograph as it was would have led to a considerably distorted figure with an exaggeratedly large head and disproportionately small hindquarters and back paws. I used the photograph simply to establish the pose of the whole animal and to refer to for any details either I had no drawings of or where my memory needed reinforcement.

Working in this way brings back to one's memory the whole process of doing the drawings from life.

Ideally, I would have returned for another sitting. That was not an option, but I had many drawings and many more photographs to serve as reminders.

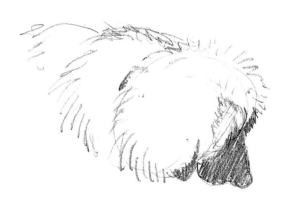

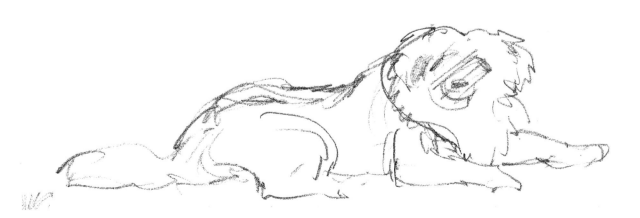

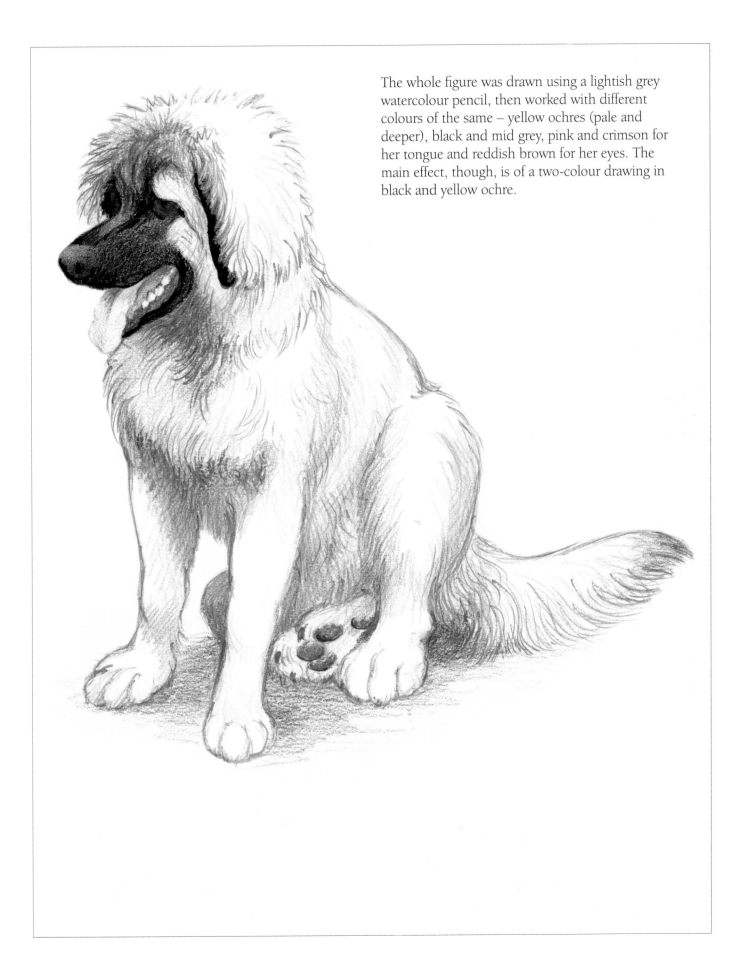

The whole figure was drawn using a lightish grey watercolour pencil, then worked with different colours of the same – yellow ochres (pale and deeper), black and mid grey, pink and crimson for her tongue and reddish brown for her eyes. The main effect, though, is of a two-colour drawing in black and yellow ochre.

WATER SOLUBLE PENCILS

by Carole Massey

Many people believe they cannot draw, but if you can sign your own name, you have all the basic drawing skills you need to create a picture. It is simply a question of training your eye and mind to draw what you see, rather than what you think you see.

A child's first drawing implement is usually a pencil, so when you begin to use water soluble pencils, they already feel familiar. Add water, and you can turn your drawing into a painting, almost as if by magic. This book will show you how to work with water soluble pencils, taking you in easy steps through the stages you need to begin creating your own pictures.

The techniques covered include drawing, understanding colour and the use of tone, as well as various methods of using water soluble graphite pencils and water soluble coloured pencils. Examples and step-by-step demonstrations help you to explore the full potential of this exciting medium.

Water soluble pencils – coloured and graphite – are ideal for both the beginner and the more experienced artist. They are user-friendly, clean, relatively inexpensive, easy to use and versatile. The transition from drawing to creating tonal washes or a 'watercolour' painting is simple, requiring nothing more complex than a brush and some water. It is true that the pencils lack the vibrancy of watercolour, but some very pleasing effects can be achieved. Some interesting textural effects can also be produced by experimenting with different types of paper.

Water soluble pencils are excellent for use out-of-doors. Lightweight and portable, they are the perfect medium for the traveller and can be used with inks, pastels, charcoal and watercolours to produce some exciting effects. As with any new skill, practice really does make perfect – so keep practising!

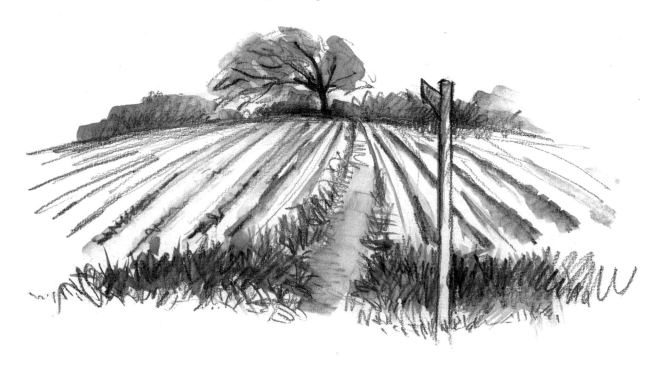

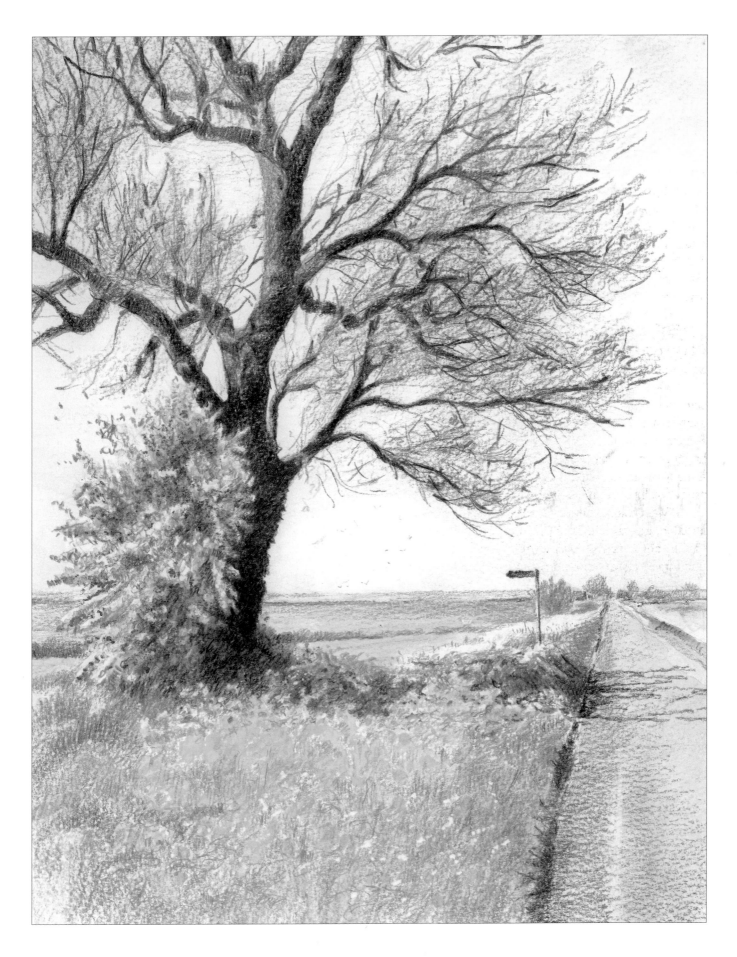

Understanding colour

Water soluble pencils come in a rainbow of colours. It is a good idea to improve your understanding of colour before you start painting, by making a colour wheel. Familiarise yourself with your own range of colours, and make some charts. Though you may think you have a wide range of colours in your set, there will often be those subtle hues you cannot match. Do not despair! In time you will learn that by blending and building up layers and washes, you can create almost any colour.

The colour wheel

Primary colours (red, yellow and blue) are those which cannot be created by mixing other colours.

Secondary colours (purple, orange and green) are made by mixing two primary colours.

Complementary colours are opposing, yet harmonious groups of colours which can be used to enhance one another or mixed to give a good range of greys and browns. They are found opposite each other on the colour wheel: blue – orange; red – green; yellow – purple.

> **Note** *The fact that cool colours appear to recede and warm colours seem to come forward can be used to create a sense of depth in your paintings if you choose carefully.*

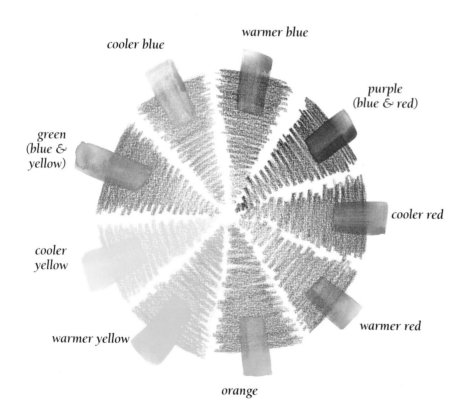

cooler blue

warmer blue

purple
(blue & red)

green
(blue &
yellow)

cooler red

cooler
yellow

warmer red

warmer yellow

orange

> ### Warm and cool colours
>
> *As you can see from the colour wheel, each colour has a cool and a warm version.*
>
> #### Cool colours (examples)
> *Yellows: lemon; zinc yellow*
> *Blues: light blue; pthalo blue*
> *Reds: crimson; magenta; carmine red; dark red*
>
> #### Warm colours (examples)
> *Yellows: cadmium; straw*
> *Blue: ultramarine*
> *Reds: scarlet lake; cadmium red; vermilion*

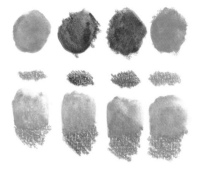

Colours which appear similar when dry can often look quite different when water is added. In the example above, burnt carmine and burnt umber are shown both dry and wet.

Greens can sometimes look quite garish, but adding a small amount of a complementary colour from the red/brown/ purple range will tone down the colour effectively.

For lively shadows, use the blue/purple range of colours, not browns and black, which can look muddy or dull.

Blend two similar colours for a more interesting, richer result, e.g. for blue sky use ultramarine and sky blue; for vibrant red use vermilion and orange; for sunlit leaves use grass green and cadmium yellow. A red next to a green will exaggerate its greenness. A touch of red mixed into a bright green, however, will calm down, or neutralise it.

Mixing complementary colours (a primary colour and a secondary colour e.g. red and green) together will produce a variety of rich greys and browns.

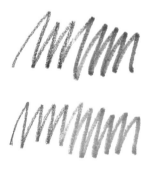

wet

dry

The colours (ultramarine and cadmium red) have been scribbled on to dry, then wet paper.

This example shows the effect of scribbling with a wetted pencil tip, which produces a paler effect as it dries out.

You can make a small palette by scribbling a colour on a spare piece of paper, and lifting the colours off with a damp brush to use on your painting.

Playing with pencils

I have drawn a variety of shells to show the different ways in which water soluble pencils can be used.

Whelk shells

The shell on the left was drawn with water soluble medium wash and dark wash, graphite pencils, without adding water.

I sketched the shell on the right using a medium wash pencil. Switching to a dark wash pencil, I added shading. With a wet brush I washed in the dark interior and the shaded parts, then with the pigment left on the brush, I painted some stripes on the shell. Wetting the graphite has created a far more interesting study and a greater range of tones.

Three shells

I used orange, brown, yellow, and blue water soluble pencils to draw the shells and their markings, adding a complementary bluish-purple shadow. I blended the colour to make the patterns using a damp brush. The blue-purple shadow area in the background, which contrasts with the colour and shapes of the shells, was painted with a wet brush.

Tropical shell

This shell had irregular markings in strong black over soft pinks and yellows, so I drew the outline with a grey pencil, then put in the lighter tints. I wetted the whole area with clean water, and used a black pencil to draw the darker, squiggly markings. I let the painting dry, then coloured in the inner scoop and the shadow using ochre, greys and browns, and wetted these to blend the colours. In some areas, I added more black or dark brown, dipping the tip of the pencils in the water where I wanted the colour to be even more intense.

Long shell

This shell was a delicate, creamy pink with fine zigzag markings. I sketched it with a pale purple pencil, adding pinks and yellows and leaving a white space in the central section, which I rubbed with candle wax. I then wetted the area and blended the colours, leaving white highlights on the 'shoulder'. I drew in the markings with orange and burnt sienna, then used a wetted purple pencil to draw in more defining lines on the left. The shadow was sketched in lightly with purple and chocolate brown, then blended with water. I scratched through the wax with a sharp blade to increase the central highlight.

Oyster shell

This shell had a highly-textured surface with lots of frilly layers and several barnacles. I used graphite and water soluble pencils, combining wet and dry methods and re-drawing with a wetted pencil where I wanted more intense colours, but leaving dry areas to create a rough texture. The complex detail was simplified to retain the overall form of the shell. I drew stronger lines at the front, with a wetted brown pencil, and left more highlights to create both shape and recession. I made the shadow blue, to complement the yellow-brown colour of the shell.

Beginning to draw

Drawing is fundamental to successful painting, and is about learning to draw what you see, and not what you think you can see. Measuring, looking at the positive and negative shapes, and understanding how to deal with tonal values will all help you to interpret accurately what is in front of you.

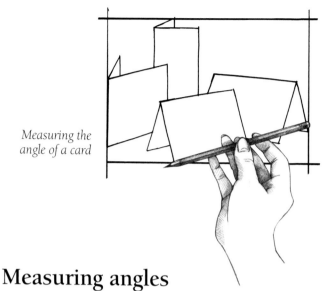

Measuring the angle of a card

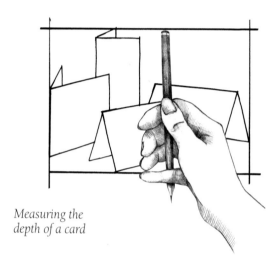

Measuring the depth of a card

Measuring angles

Lines which are neither vertical nor horizontal can be difficult to achieve. One way to do this is to line up your pencil with the element of the composition you wish to draw. Holding the pencil at the same angle, lower it to check the corresponding line on the drawing. Adjust if necessary.

Measuring proportions

Arrange four cards in a group. Plan the area and shape of your drawing by measuring the comparative height and depth of the group.

Hold the pencil vertically at arm's length with your arm straight. Close one eye and line up the top of the pencil with the highest point of the tallest card, then slide your thumb down to line up with the lowest point of the nearest card. Keeping your thumb on this mark, turn the pencil to a horizontal position and compare the width. Sketch in a box which represents these proportions.

Now plan the positions of the cards, starting in the centre. Check the relative height and width of each one, making sure you are happy before moving to the next. Keep looking at the whole composition, gradually building up an accurate picture. When all four cards have been drawn, adjust if necessary.

Positive and negative shapes

The positive shape of objects is often so familiar that preconceived ideas about how they look can hinder your approach to drawing them. Concentrating on the *negative* shapes between and around objects will give you an impartial, more accurate approach.

In the illustration above I have painted the negative shapes in blue, orange, purple and green. Another good exercise is to draw a chair looking only at the negative shapes.

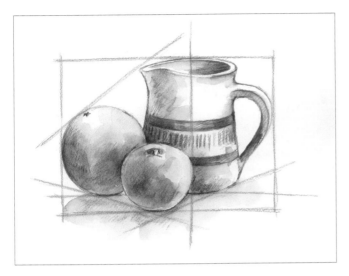

Understanding tone

Tone is how dark or light a subject appears compared to its surroundings. It is independent of, and often more important than, colour in a painting.

One of the reasons a painting may look flat or dull is lack of tonal contrast, so it is important that you understand how to use tone. A dark object may appear quite light in parts, and a pale object may have some very dark areas. Translating these tones will give your painting depth and vitality. Screwing up your eyes will help you to judge the darkest and lightest areas more easily.

Drawing position

Sit facing your subject and try to work with your sketchbook or board as upright as possible. Draw from the shoulder or elbow, not just from the wrist. Stand up and walk away from your drawing every twenty minutes or so. You will be surprised how easily you will be able to spot any mistakes.

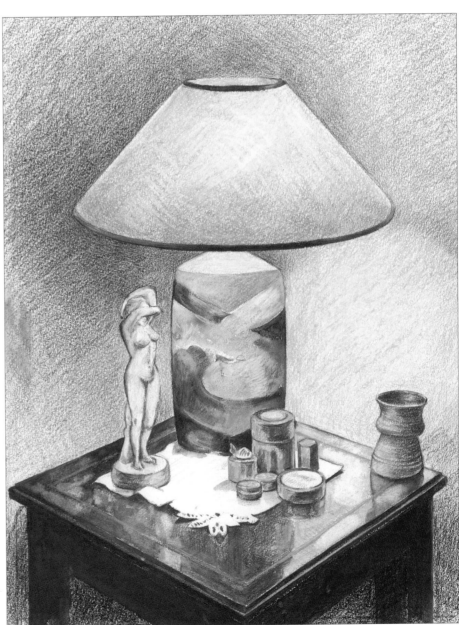

Still Life with Lamp

It is the tone, rather than the colours, which make this composition work. The table is dark brown, but seems as light as the lamp where it is reflecting the light. Successive layers of colours were blended before adding water. The background and lampshade were left dry.

Texture

Sometimes a small detail can make just as interesting a painting as a landscape. While I was looking at old barns, I noticed many interesting textures and corners that I wanted to paint, so I took lots of close-up photographs to work on later. Back in the studio, I had great fun. My water soluble pencils gave me the freedom and versatility to meet the challenge of mimicking some of the fascinating textures and colours. All the examples shown are painted on stretched HP paper.

Bale of fencing wire
I drew the shapes of the wire with a range of blues and greys, then filled in with pinks, yellows and purples, leaving the white paper to show through in the foreground as a contrast with the dark tones inside.

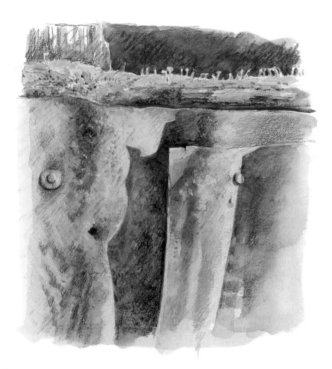

Corrugated iron
I love the shape of the contorted shadow, and the green lichen which looks like a tiny army standing along the top of the rotting wood. I used a full range of colours, and successive layers of washes to enhance this colourful corner. Even though the shadow on the corrugated area is dark, I have retained lots of warm colours here to make it glow.

Rust
I coloured in the background with a pale turquoise pencil, then added water. While the paper was quite wet, I made splodgy marks with burnt sienna, golden ochre, raw sienna and chocolate brown. I dropped in pencil scrapings as well, and let drops of water fall onto the coloured areas, forming 'cauliflower' effects (run-backs).

Old gate

I used several browns to create the background colour of the wood, which I then wetted. I allowed the wash to dry, then began to draw in the grain. The process was repeated, leaving dry pencil on top for maximum texture.

Hinge and door

Bright sunlight enhanced the shadows on the peeling paintwork. I created washes of raw sienna and pale green, letting them dry before reworking them with a dry pencil, gradually building up the textures of the rust, the paint, and the grain of the wood. I used wetted indigo and black pencils to draw in the very dark shadows and tiny holes, and left lighter highlights around the areas of rust.

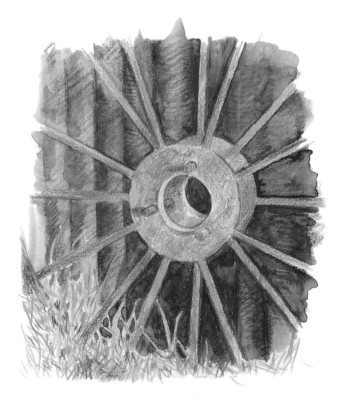

Rusty wheel

Greens, ochres and pale browns – mostly left dry – were used for the hub and spokes of the wheel, and dark blues and indigo washed in for the dark shadows on the corrugated iron.

Windmill on Water

Nothing can replace on-the-spot sketching or painting, so make time to sketch as well as taking photographs. This helps to create a better composition by combining the atmosphere captured in a sketch with the accuracy of photographs. In this case, I wanted to make sure the horizon line did not bisect the painting – remember the rule of thirds.

The sails of this windmill proved quite difficult to capture, so I used an enlarged photocopy of the scene, drew over it on tracing paper, then traced the image down on the paper. Some of the struts outlined against the sky were too fiddly to paint round, so masking fluid was ideal for this project.

I did not want the blue boat in the foreground because it would have dominated the picture. There was a constant stream of people walking along the towpath, so I added some figures for scale and interest. Although the reflections are lovely, there is quite a large stretch of water in the foreground. Adding a family of swimming geese breaks this up as well as leading the eye into the picture.

You will need:

Stretched HP paper
Tracing paper
Fine felt-tip pen
Tracing-down paper
Masking fluid
Silicone-tipped shaper
HB pencil
Water soluble pencils
Brushes: Nos. 10 and 8
Water pot
Putty eraser
Dip-pen or ruling pen
Absorbent paper

Source photographs

128

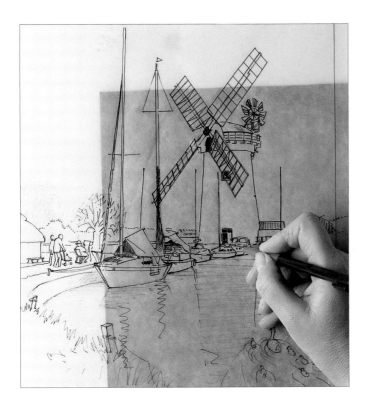

1. Plan your composition on tracing paper using a fine felt-tip pen. Transfer the image to watercolour paper using tracing-down paper and a harder pencil or an old ballpoint pen. Do not press so hard that you dent the paper!

> **Note** Do not scribble over the masked areas – the pressure of the pencil point may lift off the masking fluid.

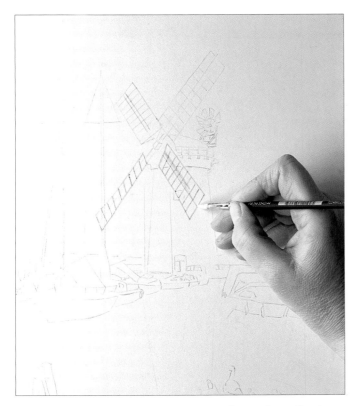

2. With a dip-pen or ruling pen, apply masking fluid in the areas where the sunlight catches the windmill sails and the mast of the boat. With a silicone-tipped shaper, mask out the geese.

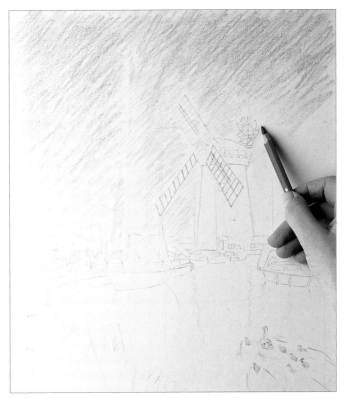

3. Sharpen some of the outlines and make guide marks to show where the reflections will fall – these can be made with the colours you plan to use in the final artwork. Scribble in the sky with a mid-blue pencil, fading towards the horizon.

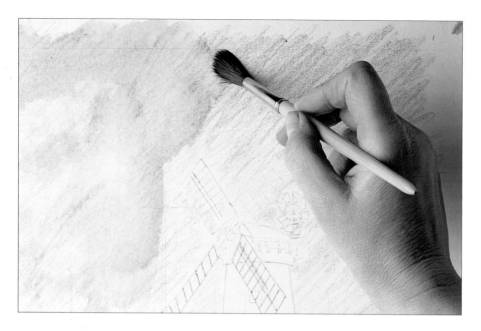

Note *If you have made some areas of the sky too dark, you can rub out some of the colour using a putty eraser before you apply water.*

4. Using a No.10 brush, apply plain water to the areas which you have scribbled.

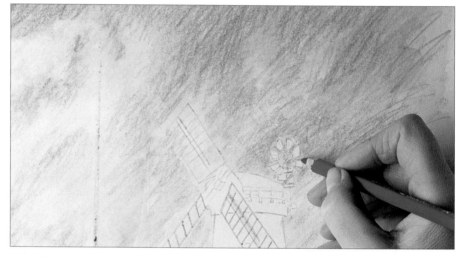

5. While the area is still wet, use absorbent paper to blot out the areas of cloud.

6. Add more of the mid-blue to deepen the effect and achieve distance in the sky. The sky should appear bluer at the top of a picture, so use a slightly deeper blue. For the white areas, simply let the paper show through. Allow the painting to dry after each stage or use a hairdryer.

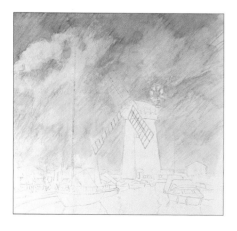

7. Add more water to the sky, blotting the clouds as you go. Allow your work to dry.

8. Using the same mid-blue, begin to add a little colour to the water. The reflected water is lighter towards the horizon, a mirror image of the sky.

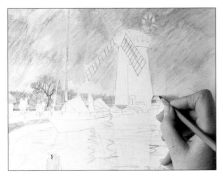

9. Add the line of trees in the background, using a darkish, blue-green pencil to suggest distance. Put in the grass behind the people on the towpath using bright green. Sketch in the willow using brown pencil, and the roofs with a slightly darker brown. With a blue-grey pencil, add the barn and small shed on the right of the mill building.

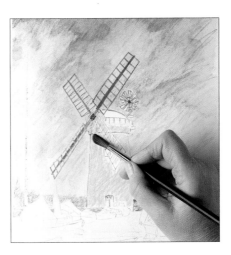

10. Draw in the sails of the windmill, taking care not to press too hard on the masked areas. With yellow ochre to give a warm undertone, hatch in the body of the mill. Add red highlights to the tail vane. With a No. 8 brush apply water to the mill building. Allow to dry.

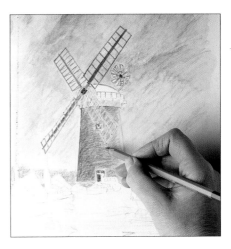

11. Put some pale blue pencil under the gantry to represent shadow – the light source is from the top right. Use a little grey pencil on the door and window areas. Build up the tones in the brickwork using reds and browns, terracotta and a little scarlet and cadmium red, tending to a purplish tone on the shady side of the building.

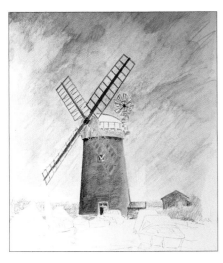

12. With a No. 8 brush, wet the body of the windmill and blend in the colours. Do not worry if it looks a little flat at this stage, because you can go back in and build up the tones by degrees. Add some blue pencil to blend in the colours on the doorway.

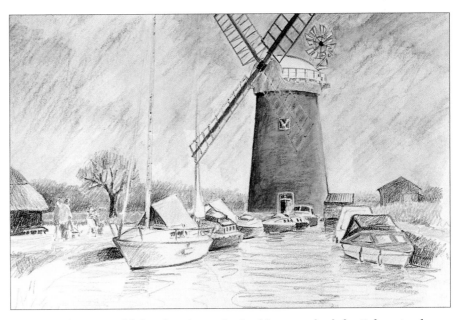

13. With brown, add the thatch on the building on the left. Colour in the figures, and add the reflection of the mill with the same colours as were used for the building. Outline the shapes of the boats using pencils in blue-grey, brown, dark red, blue and black. Begin to define the edges of the banks in varied brown shades.

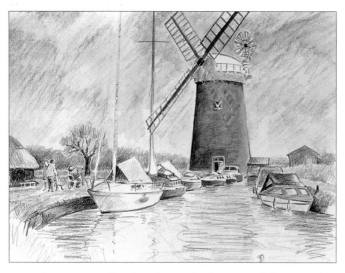

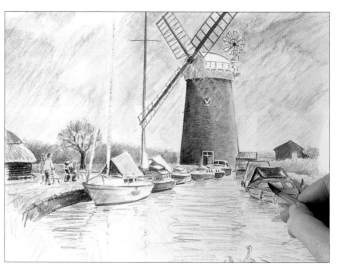

14. Sharpen up the details on the boats and the people on the towpath. Using a variety of browns, continue painting the edge of the canal bank and add the reflections to the water.

15. With a No. 8 brush, add water to the boats, the people and the mill building. To paint in small details – such as the people – you can simply pick up a little colour from another area on your brush. Put some brown pencil on the top part of the mast, then add water and blend it in.

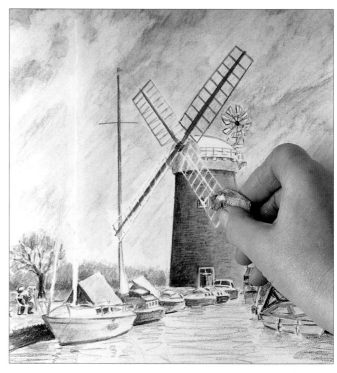

16. Scribble in the foreground grass using yellow, then wash it in using plain water and a No.8 brush. With a wet-into-wet technique, add green tones ranging from medium to dark. Allow to dry, then use brown pencil to add more details including the post on the bank.

17. With a putty eraser, remove the masking fluid from the sails and the mast of the boat on the left.

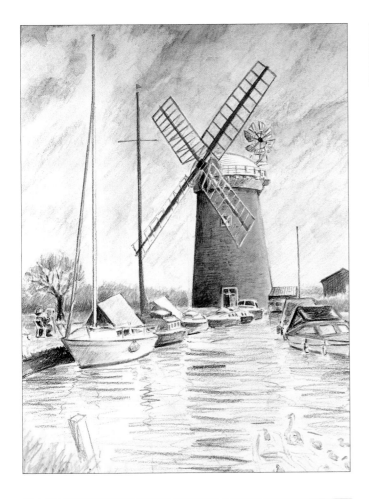

Note *Use a sandpaper block periodically to sharpen the tip of the pencil as you work.*

18. Add detail to the mast on the left with a sharp, blue-grey pencil, using a rule to obtain a clean line. The line should be darker where it passes over a light area of sky, or the finished effect will be wrong. With black and ultramarine blue pencils, sharpen up the detail on the sails.

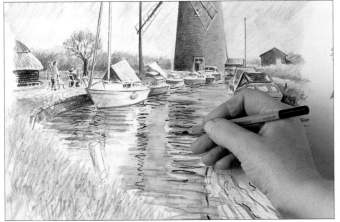

19. With a No. 8 brush, add water to the reflections, drawing into them with the wet brush but allowing some white paper to show through. Using a wet-in-wet technique, add colour to some areas to vary the effect. Use the brush to take a small amount of colour from a blue pencil and apply directly to the wash to soften it. Add the wake behind the group of masked geese by painting on ultramarine, yellow and a little yellowy gold, then adding some black pencil.

20. Using a blue wash, paint round the outlines of the group of geese to make them stand out on the paper. Allow your work to dry thoroughly, then remove the masking fluid.

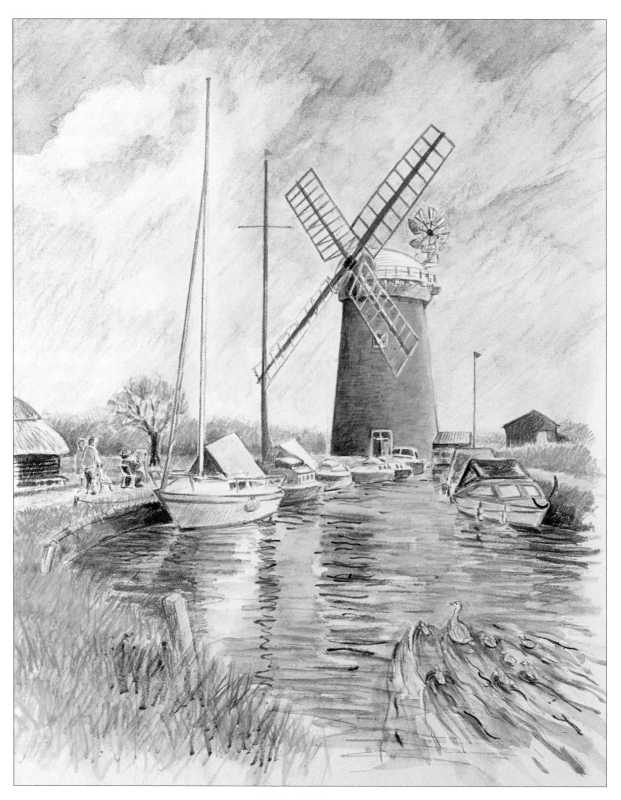

The finished painting

The painting has been worked over to refine details, darkening the river bank to make the boats stand out better and softening the wake behind the geese so they lead the eye into the composition rather than drawing it down. Stubby pencils are useful for this as they give a softer effect and make a broader mark.

Pond and fishes

I used a pale blue tinted Bockingford paper, which is left unpainted in some areas for the reflections of the sky. For the very dark reflections, I drew into wetted areas with indigo, Delft blue and black to intensify the colour. The foreground leaves were very bright, so I used lemon, bright green and cadmium yellow; for the waterlily leaves a mixture of cooler greens and blues was used in layers. I added some white with stubby pencils to brighten the highlights on the water.

Garden

The main feature of this composition is the statue from the photograph below left. I would like it to be approximately a third of the way in from the right edge of my picture, balanced by a splash of colour provided by the urn of marigolds in the photograph (below right) occupying the focal point of the foreground. These elements will therefore be arranged in line with the rule of thirds.

The photographs were taken on a bright, warm summer day and I want the painting to retain this feel. The source of light in the main photograph is strongly from the right, so I will adjust the shadow on the pot of flowers accordingly. Adding a path between the urn and the statue will lead the eye into and round the main feature, and will also offer a change of texture. Too much foliage and grass would make the composition fussy.

The predominant colour is green, so highlights of both warm and cool colours should be added throughout to provide interest; look at the colour wheel on page 120 to find complementary colours. Use blues and purples for the shadows, which should be as interesting visually as the rest of the picture; look for their negative shapes. The strong light and shade will help to define leaf patterns.

I particularly like the various types of foliage. I will use different marks to delineate them, and I will heighten the colour of the large leaves on the rheum (a plant of the rhubarb family) to make them stand out from the rest of the foliage.

The source photograph

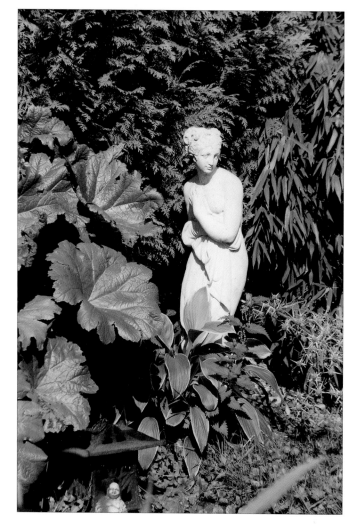

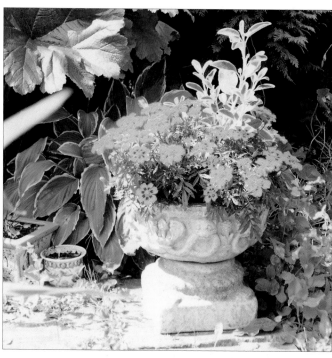

This urn – a detail from a second photograph – will be used to add colour and interest to the composition.

You will need:

Tracing paper
Tracing-down paper
Watercolour paper
Graphite pencils
Water soluble pencils
Brushes Nos. 8 and 5

1. Draw a grid on tracing paper to overlay the main photograph. Sketch in the main elements of your composition.

2. The finished painting will be about two-and-a-half times larger, so make up another grid, enlarged in proportion, on tracing paper and sketch in the statue, the foliage, the urn and the path.

Note *When transferring outlines, use a shade of pencil which will blend in with the colours of the painting, but will still be visible enough for you to follow the outlines.*

3. Transfer the main outlines of the picture to your paper. Note: I have altered and re-positioned the urn to make a better composition. Sketch in the outlines of the statue and the foliage with medium and dark tones of graphite pencil. Block in colour between the leaves with mid-green, and the flowers in the pot with bright yellow and orange. Scribble in the path with raw sienna. Outline the bamboo leaves and sketch in the conifer with blue-green pencil.

137

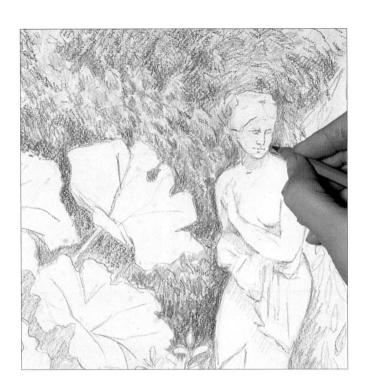

4. With a cool yellow pencil, put in some of the tones of the foliage on the conifer. With blue-green, put in a few well-defined leaves. Add the shadows with dark violet, and accent a few of the leaves with bright emerald green.

Note *Do not attempt to put in all the leaves: a few well-defined leaf shapes will effectively signal the type of foliage.*

5. Add some colour to the bamboo leaves with a warm, gold-toned yellow, a yellowy-green and a bright emerald green. Use violet and indigo to pick out areas of shadow between groups of leaves, adding indigo to tone it down if it looks too vivid.

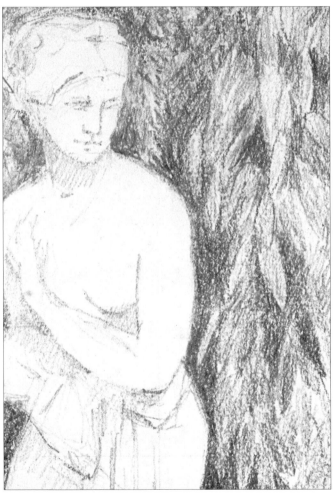

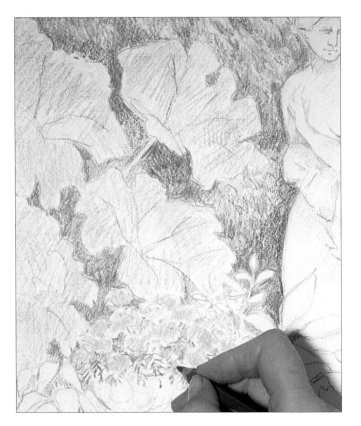

6. Start to build up colour on the rheum leaves with gold, then orange, then bright green. Draw in the ribs using darker green and red. With indigo, put in some darker shadows between the leaves. Put in the foliage between the flowers in the pot using sap green, then add orange, brighter yellow and red accents to the flowers to make them stand out.

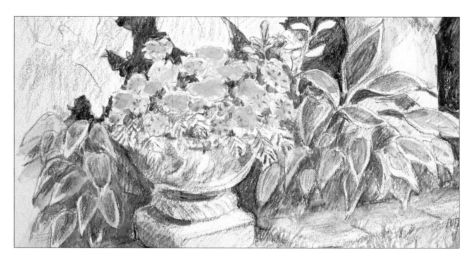

7. Build up the shadows on the urn with ultramarine pencil, remembering that the light is coming from the right. With dark brown, add the earth in the urn. Build up the tones of the hosta leaves using layers of green and yellow. Sharpen up the edges and stalks of the leaves with dark green, then add some shadow with violet and purple.

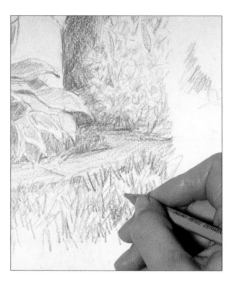

8. Build up the foliage on the right of the statue using a golden brown for the star-shaped parts of the seed heads and indigo for the shadow. Put in the foreground grass with a range of greens, choosing the shades by eye as you build up the tones.

9. Soften the colour of the statue with a touch of gold pencil. Put in some cobalt blue for the shadows – as graphite has already been used for the outline, adding more grey would make the effect too dull.

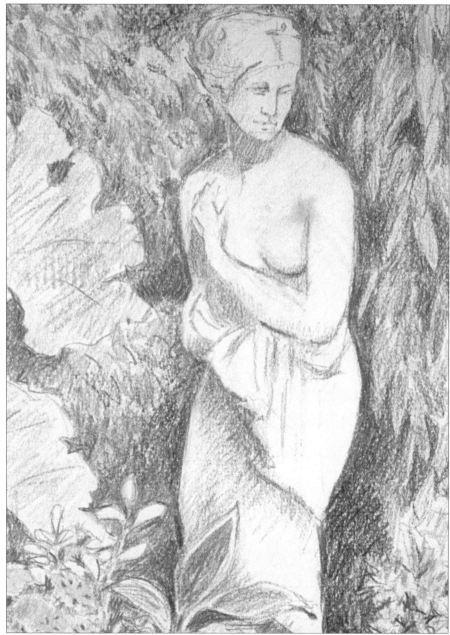

139

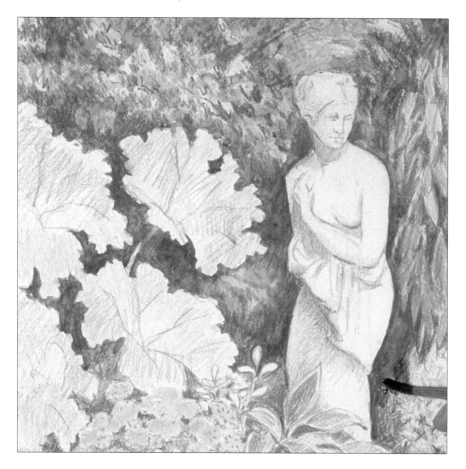

10. With a brush, add water to the foliage in the background. Using a wet-in-wet technique with blue-green, indigo and violet pencils, increase the tonal range by deepening shadows and re-defining the lighter areas of foliage. Do this in small sections, working over each area thoroughly before moving on to the next. Work round the edges of the rheum leaves to give them a more crinkly appearance.

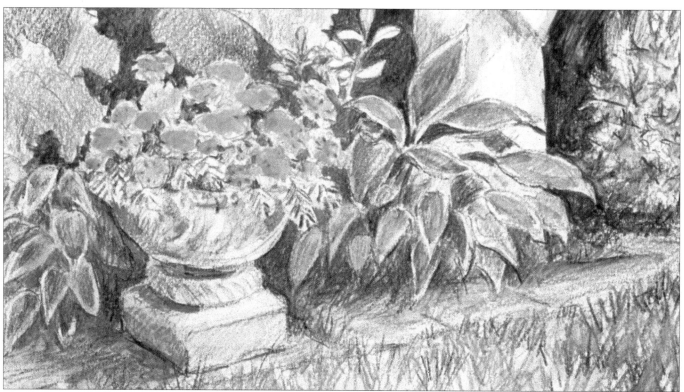

11. Add water to the foreground of the picture, and work over it in sections as for the previous stage, using the same colours.

140

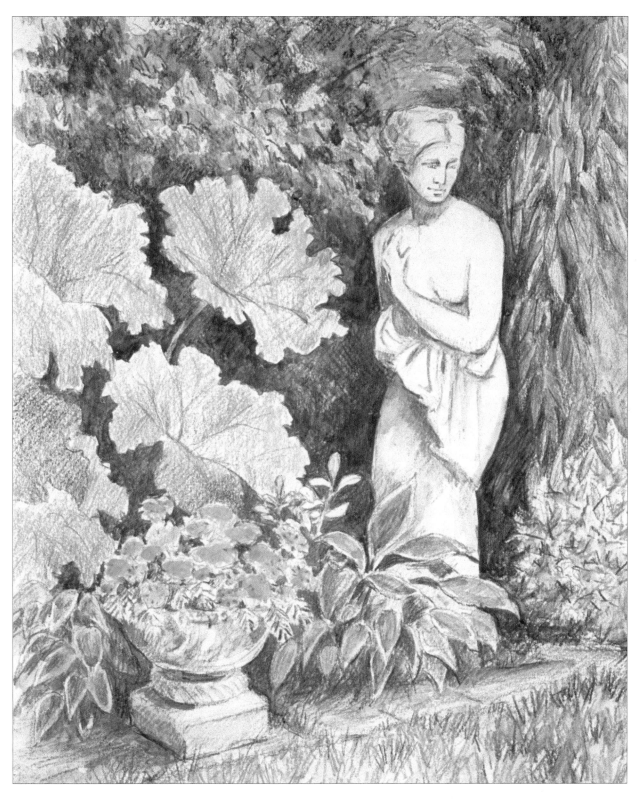

The finished painting

*I have increased the tonal value of some of the leaves by
intensifying the shadows with blues and purples to make
them stand out more. A little more orange has been
added wet-in-wet to the flowers.*

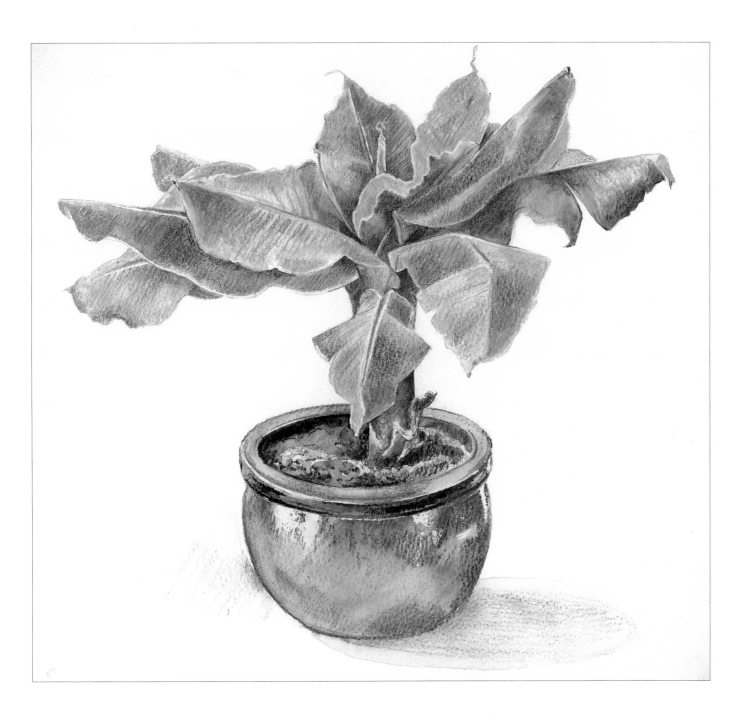

Banana plant

The plant had overwintered in a corner of my studio. I made an initial sketch to assess the tonal values – the lights and darks give the leaves their shapes. Then I drew the plant with two greens and pale ochre for the leaf tips, adding highlights on the edges with a pen and masking fluid. I masked highlights on the pot and drew it in bright blue, letting the texture of the paper show through. I added water, let it dry, then simulated the glazes by adding dry pencil. I blended the colours in the painting with a damp brush, adding more colour to strengthen some areas and drawing straight into the wet paper for intense effects like the earth in the pot.

Opposite

Hollyhocks

I wanted to show the exuberance of these stately summer flowers, so I kept the painting fairly loose and worked on stretched grey pastel paper. I adjusted the background by adding dark blues and cool greens behind the palest buds, and lightening areas behind the darker flowers and leaves to make the subject stand out from the paper.

Index

Blackberries **by Richard Box**
297 x 210mm (11¾ x 8¼in)

Coloured pencils on cartridge paper.